Digital Photography

Prentice Hall
is an imprint of

Harlow, England • London • New York • Boston • San Francisco • Toronto • Sydney • Singapore • Hong Kong
Tokyo • Seoul • Taipei • New Delhi • Cape Town • Madrid • Mexico City • Amsterdam • Munich • Paris • Milan

PEARSON EDUCATION LIMITED

Edinburgh Gate
Harlow CM20 2JE
Tel: +44 (0)1279 623623
Fax: +44 (0)1279 431059
Website: www.pearsoned.co.uk

First published in Great Britain in 2011

Pearson Education is not responsible for the content of third party internet sites.

ISBN: 978-0-273-72351-6

British Library Cataloguing-in-Publication Data
A catalogue record for this book is available from the British Library

Library of Congress Cataloging-in-Publication Data
Bluttman, Ken.
 Digital photography in simple steps / Ken Bluttman.
 p. cm. -- (In simple steps)
 ISBN 978-0-273-72351-6 (pbk.)
 1. Photography--Popular works. 2. Photography--Digital techniques--Popular works. I. Title.
 TR149.B47 2009
 775--dc22

 2009051133

10 9 8 7 6 5 4 3 2 1
14 13 12 11 10

Designed by pentacorbig, High Wycombe
Typeset in 11/14 pt ITC Stone Sans by 30
Printed and bound in Great Britain by Scotprint, Haddington

Digital Photography

In Simple steps

Ken Bluttman

Use your digital camera with confidence

Get to grips with digital photography tasks with minimal time, fuss and bother.

In Simple Steps guides guarantee immediate results. They tell you everything you need to know on a specific technology subject; from the most essential tasks to master, to every activity you'll want to accomplish, through to solving the most common problems you'll encounter.

Helpful features

To build your confidence and help you to get the most out of your digital camera, practical hints, tips and shortcuts feature on every page:

 ALERT: Explains and provides practical solutions to the most commonly encountered problems

 HOT TIP: Time and effort saving shortcuts

 SEE ALSO: Points you to other related tasks and information

 DID YOU KNOW? Additional features to explore

WHAT DOES THIS MEAN?
Jargon and technical terms explained in plain English

Practical. Simple. Fast.

Dedication:

This one is for my sister and brother-in-law, Dill and Kirk. When I told Dill I was writing a book on photography, she jumped through the ceiling with glee, exclaiming, 'We've been saved from photography wasteland!'

Author's acknowledgments:

Sincere thanks to Katy Robinson, Steve Temblett, Emma Devlin and the great team at Prentice Hall/Pearson. To Neil Salkind and Studio B, as always, the best agent and agency in the land – or rather now, should I say, across the continents. Thanks to all the creative souls who work with images and imagery. May this book be a help.

Publisher's acknowledgments:

The publisher would like to thank the following for their kind permission to reproduce their photographs:

Pearson Education Ltd:

Pages viii and 74 Photodisc. Neil Beer; Pages 12, 90 and 106 (top left, top right and bottom right), Pearson Education Ltd. Jules Selmes; Page 14 Dynamic Graphics, Inc.; Page 22 Photodisc. John Wang; Pages 24, 62, 156 and 168 Pearson Education Ltd. Ikat Design. Ann Cromack; Page 44 Photodisc. Karl Weatherly; Pages 46 and 202 Photodisc. Life File. Andrew Ward; Pages 66, 127, 140 (bottom),143 Imagestate. John Foxx Collection; Pages 72 and 152 Digital Vision. Robert Harding World Imagery. Jim Reed; Pages 76, 138 and 178 H. Wiesenhofer. Photolink. Photodisc; Pages 83 and 122 Pearson Education Ltd. Gareth Boden; Page 88 Digital Stock; Page 106 (bottom left) Phovoir. Imagestate; Pages 108 and 126 Pearson Education Ltd. Lord and Leverett; Page 124 Photodisc. Jeremy Woodhouse; Page 128 Pearson Education Ltd. Tudor Photography; Pages 136 and 218 Photodisc; Page 140 (top) EasyWind. Alamy; Pages 141 and 149 Corbis; Page 144 Richard Smith; Page 145 Artville. Dennis Nolan; Page 148 J. Luke. Photolink. Photodisc; Page 176 Photodisc. Ingo Jezierski; Page 200 Photodisc. Sexto Sol. Adalberto Rios Szalay; Page 214 Photodisc. Weststock.

Every effort has been made to trace copyright holders and we apologise in advance for any unintentional omissions. We would be pleased to insert the appropriate acknowledgement in any subsequent edition of this publication.

Contents at a glance

Top 10 Digital Photography Problems Solved

Contents

Top 10 Digital Photography Tips

1 Buying your camera

2 Digital camera basics

3 Camera accessories and things to carry

6 Lenses and light

7 People

13 Sharing your photographs electronically and online

14 Printing

Top 10 Digital Photography Problems Solved

Top 10 Digital Photography Tips

Tip 1: Understanding megapixels

Simply put, a megapixel is one million pixels. Cameras are rated with a mexapixel capacity, such as 7.2 mexapixels, 10.1 megapixels, and so on. The biggest factor of the megapixel rating is the size of photographs that can be made from the images taken with the camera. Consider that a photograph has a width and height. These dimensions are a factor of the resolution – the camera's mexapixel rating. Photographs can and often are resized with a graphics software program.

1 When purchasing a camera, don't make your decision solely on the number of megapixels. Any new camera will have more than enough megapixels to take great photographs.

2 Consider the other camera features, such as zoom and a self timer.

🔥 **HOT TIP:** If you are in the market to purchase a camera you might consider last year's model to save a few quid. Whatever megapixel rating is the rage of today didn't exist two years ago. The best cameras of the recent past are now out of favour, but within the past year or two were a 'must have'. A camera with a 10.1 megapixel rating can easily create posters. Do you need that capability? Or do you wish to email photos of the kids to the family?

Tip 2: Introducing file types

Digital cameras do not create photographs per se: they create image files. The common file format is the JPEG. Your camera defaults to this format. You do not even need to think of much more than the fact that you are creating 'Jpegs'.

The next two file formats are TIFF and RAW. These are options on higher-end cameras.

 HOT TIP: RAW is for professional photographers. If your camera does not have an option to save RAW files don't give it a second thought.

 DID YOU KNOW?

A JPEG file ends in the .jpg file extension. You might need to know this based on the sophistication of your image editing software.

WHAT DOES THIS MEAN?

JPEG: This follows a compression algorithm. More visual information can be crammed into a smaller file size, but at the loss of some definition. JPEG files can be adjusted to varying levels of quality. Your camera may or may not give you control over this. If not, it will be shooting at best quality. JPEG is an acronym for Joint Photographic Expert Group – the group that created the format.

TIFF: This is a format that that compresses visual information into a smaller file size, but does not lose any quality. TIFF is an acronym for Tagged Image File Format.

RAW: This format contains the raw image data. No processing based on the settings of the camera is saved into the file. The file is later edited in a graphics program.

Tip 3: Memory

Cameras are quite similar to computers: they create and store files. The files have to reside in some type of memory. This memory is available as a memory card. Memory cards slide in and out of a camera.

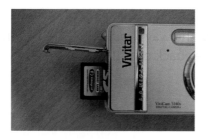 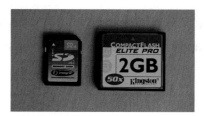

There are various sizes of memory card – both the physical size and the storage capacity. Physical size differs based on the brand of camera. Most cameras take one size of memory card but some high-end cameras can take more than one card type.

Regardless of the type (and physical size) of the memory card, every card contains a given amount of memory storage – the actually memory itself. Memory cards might hold as little as a handful of megabytes, and up to several gigabytes.

The megapixel rating of your camera determines how much memory a photograph needs. A single photograph needs roughly 1–2 megabytes for a camera that shoots in the 8–10 megapixel range. Rounding this out, a 1 gigabyte memory card can hold several hundred photographs.

1 Open the door to the inner compartment where the memory card sits.

2 Eject the card. Depending on the camera, there may be an eject button otherwise pressing on the memory card itself will eject it if it sits in a spring-loaded holder. Check your user guide.

 DID YOU KNOW?

A megabyte is one million bytes, and a gigabyte is one billion bytes. So, a gigabyte is 1000 megabytes.

? DID YOU KNOW?

A memory card can stay in the camera indefinitely. If the camera is hooked up to a computer through the USB port then all the files can be copied or erased directly from the computer. Read your user manual for specifics.

Tip 4: Protect the lens

Cameras must be treated with care. If a lens becomes scratched, the scratch will appear on all the photographs. There is no recourse for a scratched lens other than to replace it. With a fixed-lens camera that means replacing the entire camera!

Fortunately most digital cameras come with an automated lens cover. When the camera is turned on the cover opens by sliding out of the way (nothing has to be removed). When the camera is turned off, the cover slides back over the lens.

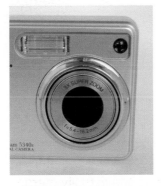

Other cameras have lenses that fit a separate lens cover. These snap on and off as needed.

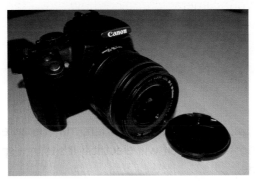

 HOT TIP: It would seem an automated lens cover is the best thing to have. However, if it gets banged it can dent and then it won't open. For this reason some consumers prefer to buy cameras that take the removable lens caps.

ALERT: Removable lens caps can get lost! Some removable caps have a built-in loop in which a thread is put through to tie the lens cap to the camera strap or somewhere else on the camera body. Then the lens cap does not get lost.

Tip 5: Learn the menu system

All digital cameras come with a built-in set of functions and settings. Taken loosely this is known as the menu system. You will meet it as you navigate through a series of computer-like menu items to change settings. Each manufacturer has a unique menu system, but the settings are common for the most part since they are settings of photographic properties. Learning the menu system of your camera can be daunting but the payoff is worth it when you start to produce photographs tailored to the way you want them to appear.

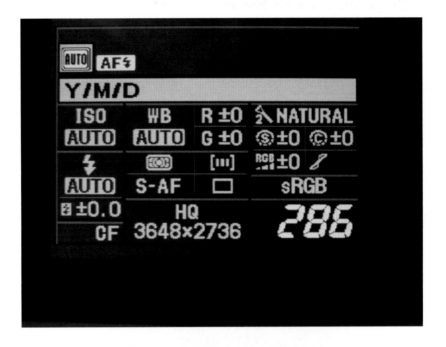

Tip 6: The shutter

The shutter is an internal part of the camera. It serves as a block against light coming into the camera. The action of shooting a photograph opens the shutter. When this happens light flows through the lens onto the internal camera elements that store the image. There are two major settings for the shutter – the amount of time it stays open, and the size to which it opens.

Most people take photographs in full automatic mode that lets the camera figure out how to set the shutter properties. This happens almost instantaneously. You press the shutter button (the button that takes the picture), the camera senses the scene, focuses, and sets the speed and opening of the shutter. The picture is taken and the result is yours to cherish.

 DID YOU KNOW?
The size of the shutter opening is known as the aperture setting. These settings are referred to as f-stops. An example is a setting of f/5.6.

Most cameras do have semi-automated settings and even full manual control. Two popular semi-automated settings are aperture priority and shutter priority:

- aperture priority – you set the aperture and the camera sets the shutter speed
- shutter priority – you set the shutter speed and the camera set the aperture.

Shutter speeds range from fractions of a second to an endlessly open shutter. Sports scenes and fast-moving subjects are best taken with a fast shutter – such as 1/250 of a second. The result is a moving, but non-blurred subject. Slow shutter speeds are needed in low light settings so there is more time for light to enter the camera. When a flash is used the shutter speed does not have to be slow. A fast shutter speed with a large aperture is similar to a slow shutter with a smaller aperture.

WHAT DOES THIS MEAN?
Exposure: The term used to convey the combination of aperture and shutter speed.

SEE ALSO: Creative use of exposure settings is covered further in Chapter 6.

Tip 7: Use the zoom, but don't overdo it

The ability to zoom in on a subject or scene is readily available on nearly all digital cameras. Like all special treatments, zoom has its use and overuse. Zooming in is needed only when you are too far away to frame the scene with the standard non-zoomed setting, or when something undesirable is in the periphery of the scene – zooming will exclude it from the viewable area.

It might be rubbish, glare, unexpected people or other extraneous elements on the sides or top or bottom of the viewing area that have to be taken out of the shot. Another issue is if there is just too much surrounding area compared with the size of the subject in the middle of the scene. Use the zoom just enough to have these distractions disappear from the edges.

1 Zoom in to the full extent.

2 Slowly zoom back out until there is a good balance of the subject and the surrounding area.

HOT TIP: Pushing the zoom to the max may make the picture fuzzy. Zoom three quarters, and if need be, walk in a few steps.

Tip 8: Shoot in burst (continuous) mode

Most digital cameras have a setting that will have the camera click away, shot after shot, while the shutter button is pressed. This is called burst mode by some manufacturers, continuous mode by others, and perhaps something else on your camera. Burst mode is something you can practically just leave on all the time because it is in your control to stop the sequence of shots by letting go of the shutter button.

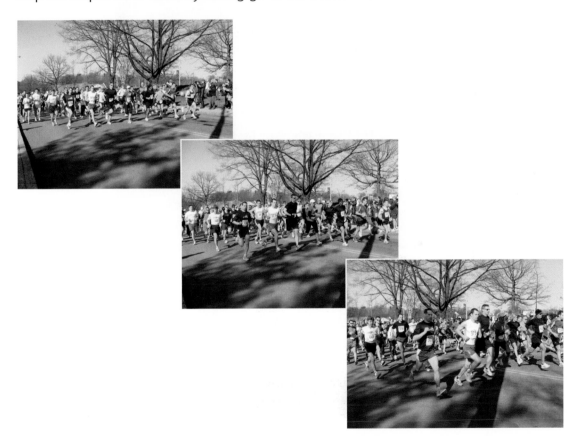

 DID YOU KNOW?
The speed at which burst mode operates can differ between camera models. You might get three shots per second, five shots per second or some other interval.

HOT TIP: When using a sequence of burst mode pictures to create a collage, consider leaving some out. For example use every other shot in the sequence. That is how the above collage was put together.

Tip 9: Shoot the info board

When visiting a new park, or on a trip or holiday, make a note of where you took your photographs. You may not think this is important at the time, but imagine someone asking the name of the park where you got that great shot – and you can't remember. There is an easy way to note this. While shooting pictures, take a picture of the information board, welcome sign, street corner name or some other identifiable marker.

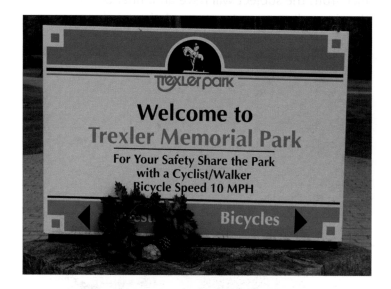

 HOT TIP: Make it a habit of taking an identifying picture when you go on a trip. This will help you to remember the name and location of where you were.

Tip 10: Shutter priority

When a camera is on shutter priority, you select the shutter speed and the camera determines the best aperture. This is useful when you need to consider subjects in motion. To capture a vehicle or sports activity without blur, the shutter needs to be fast. Useful speeds for action are 1/125 of a second or faster. The speed of the active subject will help make you decide on the shutter speed. A racing car is much faster than a runner. Also distance from the subject will have an influence. The further you are from a moving subject, the slower it appears to move relative to you.

1 Turn the dial on your camera until the shutter priority setting is selected.

2 Depending on the camera, the selection for shutter priority might be made through menu selections instead of a dial. Check your user guide.

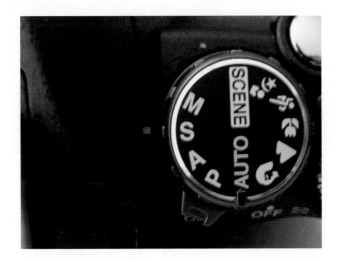

 HOT TIP: If it seems difficult to determine a shutter manually, then don't. Full auto will be fine in nearly all situations. Many cameras also have a preset for sports photography.

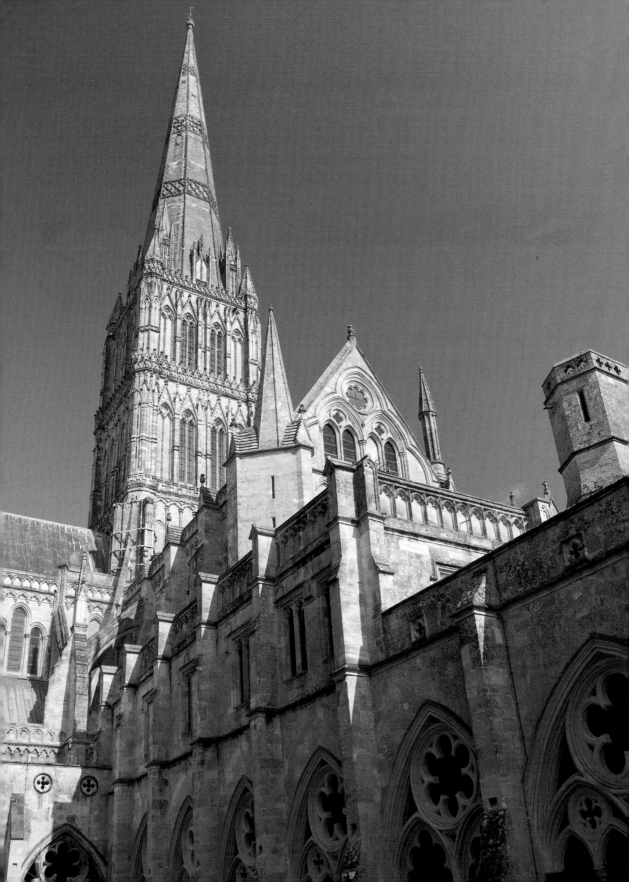

1 Buying your camera

Introduction

Photographs are memories preserved for a long, long time. Photographs are captured images of people or pets doing funny things. Photographs are works of art.

Whatever your need for a camera, remember the first rule when using one is to have a good time. Photography is a joy to most (journalists would disagree and state it's a job). But this is a book for the rest of us.

Buying a camera is not the biggest purchase of your life, and depending on how much you spend, might be less than many other necessities: clothes, appliances or even food shopping. In other words, you can go full tilt and buy a knockout of a camera, or be reasonable and buy one that serves your basic needs.

Appearance and size

Cameras come in many sizes and styles. Although for the most part they are the same inside, the appearance of the camera is what will catch your attention. The camera might be blue, silver, pink, leopard skin or even clear. There's a camera to match every taste.

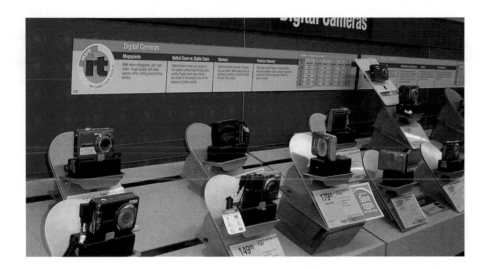

What's also important is how it feels in your hand. Pick up a camera, feel how heavy or light it is, take a pretend picture. Does your finger easily reach the shutter button? No? Try another. Consider too the size – does it need to fit easily in your handbag or your pocket? There's no sense buying a camera that is difficult to fit somewhere you want when carrying it around.

1 Take your time: pick up a camera, feel it, look it over and then do the same with other models.

2 An outrageous-looking camera might seem like fun at first, but consider if you will eventually tire of it and wish you had one with a traditional appearance.

 HOT TIP: Don't forget that you will likely be getting a soft case for the camera, so think of the extra room that will take up as well.

Measuring the megapixels

The biggest property of the camera you will hear about is its number of megapixels. You may be swayed to buy a camera on this factor alone – the more megapixels, the better it is. Correct? Not necessarily. Any modern camera has more than enough megapixels to provide you with wonderful standard-sized photographs.

If you desire to have posters printed of your photographs then a higher number of megapixels is helpful, but take the number into consideration here too. A camera with 8 or 10 megapixels can produce rather large posters. So you may consider skipping the 12 or 14 megapixel cameras.

1 Ask the salesperson to demonstrate the different print sizes that can be made from different numbers of megapixels.

HOT TIP: Other camera qualities such as the zoom and battery life should be considered even more than the megapixels.

Viewfinder or LCD?

The viewfinder is the small window that you put to your eye when shooting a photograph.

The LCD is a panel that is on the back of the camera and may actually swing out for ease. When you take a photograph using the LCD, you look at the scene in the LCD without the need to put your eye right next to it. Some cameras have both a viewfinder and LCD.

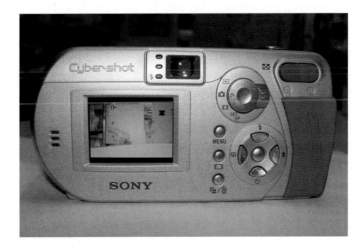

There is no particular advantage or disadvantage on which you choose. It's a matter of preference.

1 Try taking pictures with both a viewfinder and an LCD.

2 See if you can do so near some sunshine or under bright lights in the shop. See which type of viewing method works best for you.

DID YOU KNOW?

In bright sunlight it may be difficult to see the image in an LCD-type camera. On the other hand, using a viewfinder for taking many photographs may give you some eyestrain from all the squinting.

Does it do video?

Many cameras have the ability to shoot short videos as well as photographs. This feature might seem unimportant and perhaps you will never use it. But then again, you may find a use for it. It is a great alternative to buying a separate digital video recorder. The length of the videos will depend on the size of the memory card in the camera.

1 Examine the settings on the camera to see if there is a video option.

2 Consider the amount of memory the basic memory card that comes with the camera has. If it is less than a gigabyte, buy an additional card. Videos take up much more room than photographs.

 HOT TIP: Videos are becoming more popular all the time. Shooting videos may be unfamiliar to you, or you feel you won't be good at it. These notions are not necessarily so. Once you start taking videos you might find a new world of fun has opened up for you.

Understanding zoom

The zoom feature may just be the number one important item to find out about. There are two things to consider: the amount of available zoom and the type. Here are two photographs – the first with no zoom and the second with zoom.

The desirable type of zoom is optical. Digital zoom, the other type, is just a function of the camera that manipulates the image to make it appear bigger. It can produce grainy looking photographs. Look for a camera with a good range of optical zoom, such as 8x or 10x. Ask the salesperson to explain the strength of the zoom factor of the camera.

 HOT TIP: While trying out a camera, see if your fingers can easily find the zoom in/out switch without looking for it. Just like the shutter button, it is best if you can keep your eyes on the scene you are taking a photograph of.

Self timer

A timer, or self timer, is a feature of the camera that provides a pause inbetween the time you press the shutter button and when the photograph is taken. The pause is in seconds, such as 2 seconds, 10 seconds, and so forth. The reason for a timer is two fold. One is for when you are taking a photograph with a slow shutter speed (explained later in the book) – so you avoid any camera jiggling disrupting the photograph.

The other reason is the popular one – so you can get in the picture! A tripod is needed, or at least a surface to place the camera on. Then with the self timer set to a high enough number of seconds, such as 10 or 15, you can press the shutter button, walk into the scene and have yourself in the photograph.

 HOT TIP: Look for a camera with a 10 or more seconds timer feature. Some cameras come with just a 2 second timer. This is not enough time to place yourself in the picture.

Batteries and the charger

A camera is all but useless without the power it needs to work. As such, the battery (or batteries) has the same importance as the zoom and other features. Batteries come in various capacities and are usually unique on the camera model or brand.

The camera will come with a battery (rarely it will not), but you should also find out if it comes with a charger. Most cameras use a rechargeable battery. If and when you become a photography heavy hitter, you may wish to purchase an additional battery so if one runs out of charge while you are out and about, you have the other to drop in place and take more photographs.

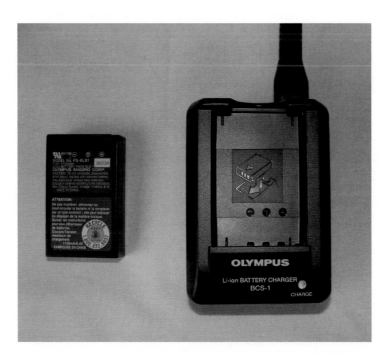

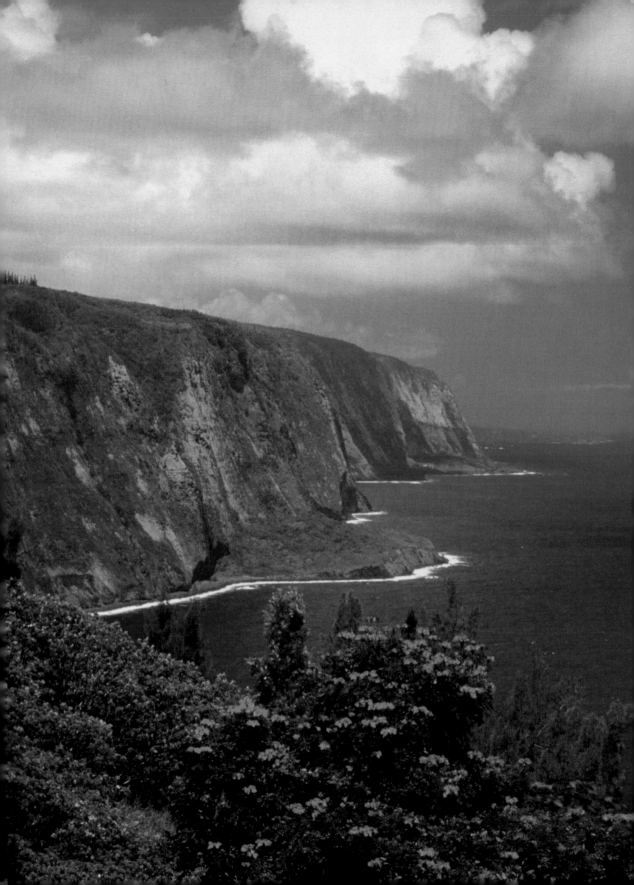

2 Digital camera basics

Introduction

If you are old enough, you will recall the days of film. You had a camera, and then you bought film, but which type? There was colour film, black and white film, film with ISO ratings of 100, 200, 400, 800, and higher. There was film that was used to create slides to view with a slide projector.

Film was costly in relative terms. As such, once you had decided about what type of film to buy, you then made a decision about roll size. Would you need to create 12, 24, 36 or more photographs?

Then with all the hard decision work behind you, you had to be careful not to take too many pictures or to waste shots. You had to pay to process the film so loathed the thought of taking mediocre shots. And even so, you didn't know how the pictures would turn out until after they were processed. How did we manage like this?

Luckily, those days are over. Film is history. Welcome to the digital age. Well, the digital age has been around for quite a while but I bet, since you picked up this book, that you are looking for a guide about mastering the wonders of digital photography. Just remember the golden rule – take as many shots as you want! But don't forget the one downside in this wonderful digital world – your batteries will eventually run out.

Introducing the pixel

The pixel is the smallest element of a digital image. Barring any unusual viewing monitor resolution settings, at a normal zoom view (100% or 'fit to screen', etc.), an individual pixel is close to indistinguishable. Pixels are so small that they blend together when viewed by the naked eye. Since they are so small, a typical photograph consists of millions of pixels.

Zooming in is the only way to really understand and literally to see the subtleties of pixels. The zoom referred to here is the type that can be done in an image editing program, not the zoom of the camera's lens. For example, here is a section of pixels found in a photograph. This image of pixels is magnified 32x normal size.

As you can see the colours of pixels can vary slightly or to a great degree. What might look like a solid colour in a photograph could be comprised of dozens of similar hues.

A single pixel can display one or more colours. This dependency is on the pixel depth of the image. Most images have a pixel depth that lets a single pixel display up to 256 colours, 65,536 colours ('high colour'), or 16.7 million colours ('true colour'). Yes, these numbers are dizzyingly hard to imagine, but this is where technology has reached.

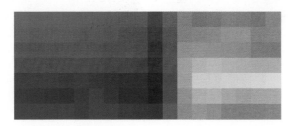

? DID YOU KNOW?

In the display of colour, another variant of what the pixel portrays is the colour's opacity. Opacity is the alter ego of transparency. Complete opaqueness displays as a solid colour. Zero opaqueness makes it invisible.

Understanding megapixels

Simply put, a megapixel is one million pixels. Cameras are rated with a mexapixel capacity, such as 7.2 mexapixels, 10.1 megapixels, and so on. The biggest factor of the megapixel rating is the size of photographs that can be made from the images taken with the camera. Consider that a photograph has a width and height. These dimensions are a factor of the resolution – the camera's mexapixel rating. Photographs can and often are resized with a graphics software program.

1 When purchasing a camera, don't make your decision solely on the number of megapixels. Any new camera will have more than enough megapixels to take great photographs.

2 Consider the other camera features, such as zoom and a self timer.

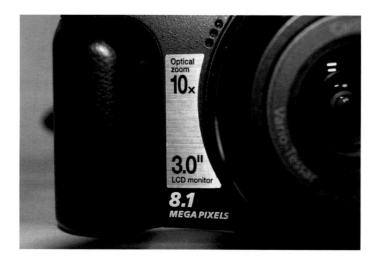

 HOT TIP: If you are in the market to purchase a camera you might consider last year's model to save a few quid. Whatever megapixel rating is the rage of today didn't exist two years ago. The best cameras of the recent past are now out of favour, but within the past year or two were a 'must have'. A camera with a 10.1 megapixel rating can easily create posters. Do you need that capability? Or do you wish to email photos of the kids to the family?

Turning the camera on and off

Digital cameras run on batteries. Therefore they all have an on and off switch or button which is located in a different place depending on the camera model (most seem to have it on the top of the camera).

1 Remove the lens cover if your camera has one that has to be manually removed.

2 Find the on/off switch and turn the camera on. Consult your user manual if necessary.

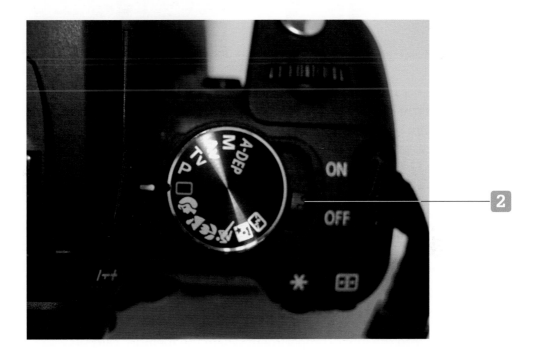

Memory

Cameras are quite similar to computers: they create and store files. The files have to reside in some type of memory. This memory is available as a memory card. Memory cards slide in and out of a camera.

There are various sizes of memory card – both the physical size and the storage capacity. Physical size differs based on the brand of camera. Most cameras take one size of memory card but some high-end cameras can take more than one card type.

Regardless of the type (and physical size) of the memory card, every card contains a given amount of memory storage – the actually memory itself. Memory cards might hold as little as a handful of megabytes, and up to several gigabytes.

The megapixel rating of your camera determines how much memory a photograph needs. A single photograph needs roughly 1–2 megabytes for a camera that shoots in the 8–10 megapixel range. Rounding this out, a 1 gigabyte memory card can hold several hundred photographs.

1 Open the door to the inner compartment where the memory card sits.

2 Eject the card. Depending on the camera, there may be an eject button otherwise pressing on the memory card itself will eject it if it sits in a spring-loaded holder. Check your user guide.

 DID YOU KNOW?

A megabyte is one million bytes, and a gigabyte is one billion bytes. So, a gigabyte is 1000 megabytes.

DID YOU KNOW?

A memory card can stay in the camera indefinitely. If the camera is hooked up to a computer through the USB port, then all the files can be copied or erased directly from the computer. Read your user manual for specifics.

Using the viewfinder

There are two ways to see what the camera is aimed at. One is to look through the viewfinder, the other is to use the LCD (liquid crystal display). Some cameras have one or the other, or both.

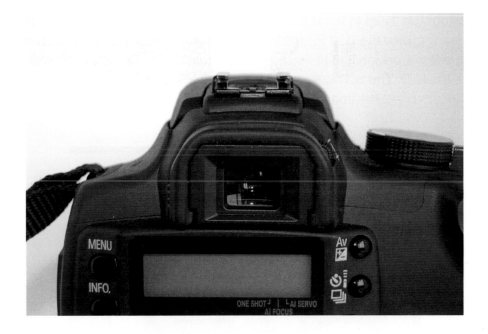

The viewfinder is on the back of the camera and you hold it up to your eye to see through it. What you see is affected by the camera settings. For example, when you zoom in, the view changes accordingly.

1 If your camera has both a viewfinder and an LCD, consult your user manual on how to switch between the two (on some cameras only one is active at a time).

2 When using the viewfinder you may have to take your glasses off. The camera will compensate for the clarity your glasses provide.

 HOT TIP: Higher-quality cameras (such as digital single lens reflex models) provide a readout that is visible inside the viewfinder. When you look through the viewfinder, on the side and out of the way of the image, you may find information about the shutter speed and aperture.

Using the LCD

The liquid crystal display (LCD) is a panel that shows what the camera is focused on. The LCD can be quite small up to a very reasonable size that makes the image easy to see. Furthermore the LCD may be on a movable plate that swings out from the camera at a right angle to provide additional ways to hold the camera and see what will appear in the photograph. Keep in mind that with an LCD you do not keep your eye close to the camera. You view the LCD from several inches away. Not all cameras have an LCD and using one is a personal preference. Some people like using the viewfinder, and others like the LCD. The LCD does make the image easier to see but in bright sunlight it can be difficult to see any image.

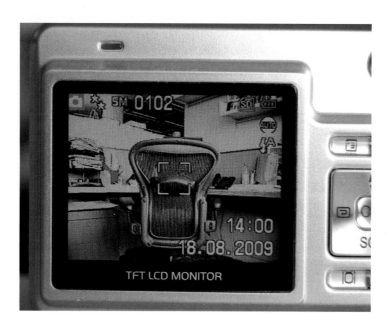

? DID YOU KNOW?
The LCD is sometimes referred to as Live View.

The lens

The lens really is the heart of the camera. Without it no photograph could be taken, as the lens puts the image into the camera.

There are many types of lens. Most digital cameras come with a single fixed lens – it cannot be removed. The alternative to this is a camera that allows different lenses to be removed and attached. These higher-end cameras are for serious enthusiasts and professionals.

A variety of lenses provides a variety of creative possibilities. There are lenses for long-distance photography (telephoto), close-up photography (macro), and everything in between. Basic consumer digital cameras have one fixed lens – with the ability to zoom. This has by popularity over the years become the leading feature that people want. The zoom range can differ from model to model.

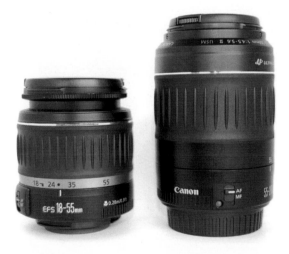

Most cameras with a single fixed lens, when turned on, extend the lens out of the camera's body. The lens retracts when the camera is turned off.

 HOT TIP: Keep an extra tripod in the boot of your car. Some lenses are big and heavy. You'll need a tripod to use them. It's a good idea to always have one with you.

Releasing and attaching a lens

Cameras that can change lenses follow a standard method of taking off a lens and attaching another to the camera body.

1. Facing the front of the camera, find the lens release button and press it. Turn the lens counter-clockwise until it detaches. Check your user manual for exact instructions.

2. To attach a lens, line up the red dots. One is on the front of the camera body, and the other is on the lens. Gently place the lens into the opening and turn it clockwise until the lens clicks into place – usually a quarter rotation will do it. Check your user manual for exact instructions.

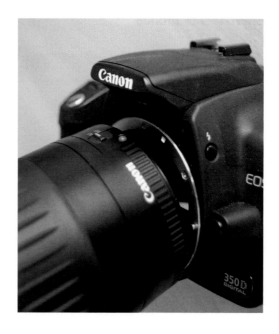

 ALERT: Change lenses in the least dusty place available and as fast as you reasonably can. Avoid dust – dust is not a photographer's friend.

The shutter

The shutter is an internal part of the camera. It serves as a block against light coming into the camera. The action of shooting a photograph opens the shutter. When this happens light flows through the lens onto the internal camera elements that store the image. There are two major settings for the shutter – the amount of time it stays open and the size to which it opens.

Most people take photographs in full automatic mode that lets the camera figure out how to set the shutter properties. This happens almost instantaneously. You press the shutter button (the button that takes the picture), the camera senses the scene, focuses, and sets the speed and opening of the shutter. The picture is taken and the result is yours to cherish.

> **? DID YOU KNOW?**
>
> The size of the shutter opening is known as the aperture setting. These settings are referred to as f-stops. An example is a setting of f/5.6.

Most cameras do have semi-automated settings and even full manual control. Two popular semi-automated settings are aperture priority and shutter priority:

- aperture priority – you set the aperture and the camera sets the shutter speed

- shutter priority – you set the shutter speed and the camera set the aperture.

Shutter speeds range from fractions of a second to an endlessly open shutter. Sports scenes and fast-moving subjects are best taken with a fast shutter – such as 1/250 of a second. The result is a moving, but non-blurred subject. Slow shutter speeds are needed in low light settings so there is more time for light to enter the camera. When a flash is used the shutter speed does not have to be slow. A fast shutter speed with a large aperture is similar to a slow shutter with a smaller aperture.

> **WHAT DOES THIS MEAN?**
>
> **Exposure**: The term used to convey the combination of aperture and shutter speed.

> **SEE ALSO:** Creative use of exposure settings is covered further in Chapter 6.

Cycling through the flash options

Flash is necessary when the lighting is dark, or you may decide for creative reasons not to use flash. No matter, you have control over how and when flash is used.

1 Most cameras have four settings:

- flash always on
- flash always off
- let the camera decide if flash is needed – as with the automatic shutter settings, the camera senses if flash is needed
- slow flash – this type of flash is used in situations where the background is dark comparative to the subject. (The shutter will stay open longer than the time of the flash – so more light is captured from the background.)

The flash mode can be selected using the flash button on the camera.

Understanding the shooting modes

There are several shooting modes provided for quick adjustment to different shooting situations. These are variations of auto settings. Generally the following are provided:

- High Sensitivity – shoots images without a flash in low lighting. An increase in the ISO setting (explained on page 41) is used to compensate.

- Soft Snap – softens the subject(s) in the image.

- Sports Shooting – takes the picture using a fast shutter setting.

- Twilight Portrait – keeps the subjects sharp and lit against a dark background.

- Twilight – adjusted settings for getting the best of low light scenes.

- Landscape – places the focus on faraway objects.

- Beach – for scenes with water; the water is rendered a deeper blue.

- Snow – compensates for bright reflective snow.

- Fireworks – perfect for bright fireworks against the dark sky.

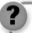 **DID YOU KNOW?**

The available shooting modes differ from manufacturer to manufacturer and model to model. Consult your user manual.

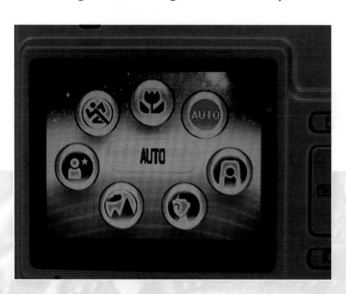

Program mode

This is a hybrid mode – something of an automatic mode, and something more. In program mode, aperture and shutter speed are handled by the camera, but other settings become available and the camera adjusts the aperture and shutter speed based on your selections.

1 Place the camera in program mode. Refer to your user manual for instructions.

2 Set the metering mode, ISO and other parameters that are available to change.

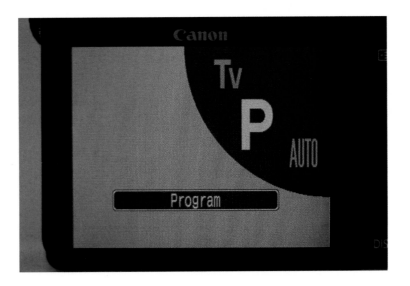

 HOT TIP: Program mode instructs the camera to set the lens aperture and shutter speed. When using Program mode you can then manually set the ISO and other settings, and can see how they affect the shot. Program mode is great for getting familiar with these settings. Check your user manual to see which settings can be set manually in Program mode.

Manual mode

This mode puts the camera settings completely in your hands. When the camera is placed into manual mode, the settings usually stay at what they were prior to changing the mode. Now it is up to you to adjust the settings.

1. Place the camera in manual mode. Refer to your user manual for instructions.

2. Select the exposure settings, metering mode, ISO and other parameters that are available to change.

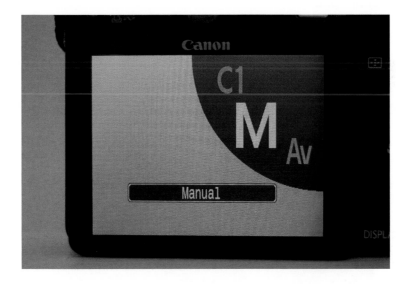

 HOT TIP: Manual mode is powerful, but will quickly lead to frustration until you are familiar with all the camera settings. Shooting photographs in aperture priority, shutter priority and program mode is best while learning how the various settings affect the outcome of the images.

Changing the zoom

The ability to zoom in and out is probably the most popular feature of digital cameras. As the zoom is applied the lens will expand or contract depending on whether the zoom is being increased or decreased. The zoom is often controlled with a rocker switch that has two values – W and T. Moving the switch towards T zooms in; applying the W side decreases the zoom.

1 Press 'T' to zoom in.

2 Press 'W' to zoom out.

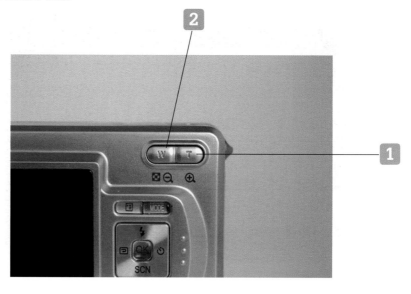

ALERT: Not all cameras indicate zoom settings with W and T.

Using the self timer

Your camera probably has a self timer with one or two settings. The self timer provides a countdown to the picture being taken. For example a camera may have a two-second timer and a 10-second timer. Setting one of these and then pressing the shutter button provides a delay before the picture is taken.

1 Set the self timer according to the instructions in your user manual.

2 Press the shutter button. The camera will count down the seconds and then take the picture.

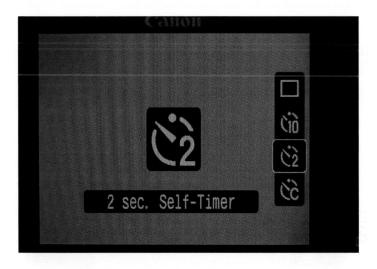

 HOT TIP: Putting the camera on the tripod and setting the timer to 10 seconds or more lets you press the shutter button and then move into the view so the camera takes a picture with you in it.

Metering modes

Metering determines how the camera measures brightness, in order to set the aperture and/or shutter speed. There are three standard metering modes:

- Multi – the camera calculates an average brightness by sampling the brightness in many areas of the image. This setting should be your default until you are familiar with how metering works.

- Centre – the camera averages the brightness between the subject in the middle and the background. More weight is put on the centre subject (mathematically speaking, this is a weighted average). This setting is useful for situations where the subject is surrounded by a background with a noticeable difference in brightness.

- Spot – the camera adjusts for the brightness just within the centre. You should see an indicator in the viewfinder or on the LCD. This indicates where in the view the camera adjusts for brightness.

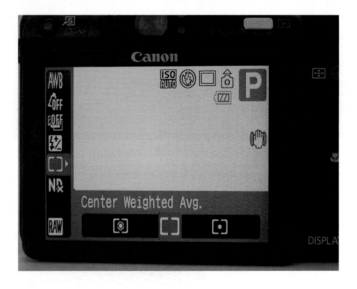

HOT TIP: It may be possible to change metering only when not in auto mode.

Setting the ISO

Traditionally ISO was the rating for film speed. This meant how fast film could absorb the light being placed on it once the shutter was opened. The concept and use of ISO carried over into the digital realm. Now instead of film being affected, the setting affects the camera's internal image sensor.

There is an auto ISO setting – the camera uses the best ISO at the time of taking the picture. Then there are the standard ratings – 100, 200, 400, 800, 1600, and possibly higher values. The lower the ISO number, the longer it takes for the sensor to absorb light. Low values (100, 200) are used for bright scenes since a low setting prevents overexposure (the photograph looks washed out).

Lower ISO settings provide better quality but are not always practical. A higher setting is needed for low light situations, but higher ISO settings introduce 'noise' – a grainy appearance. On the other hand a high ISO setting is less likely to produce any blur from hand shaking while taking the picture. With a high setting the camera absorbs light fast, so a fast shutter speed comes into play to avoid overexposure. A fast shutter speed makes it less likely that blurring will occur in the photograph. Experiment with ISO settings to discover how best to apply them.

1 Using the menu system, select an ISO value. Check your user manual on how to do this.

2 Shoot the same scene with different ISO settings to see how ISO affects the shot.

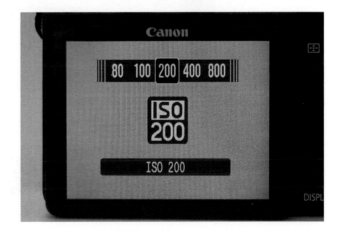

 HOT TIP: It may be possible to change ISO settings only when not in auto mode.

 DID YOU KNOW?
ISO is the acronym for the International Standards Organization that provides the standards for a wide range of subjects. In photography the acronym itself is used to indicate film speed.

Setting the EV

EV (exposure value) is a setting to offset slightly the exposure (aperture and shutter speed). An EV of 0 means there is no offset. EV in most cameras can occur anywhere in the range of –2 through to +2. A number above 0 creates a brighter image; a number below 0 creates a darker image. As a rule of thumb, think of EV as a way to brighten or darken the picture.

1 Access the EV menu. Refer to your user manual for instructions.

2 Set the EV value up or down as desired.

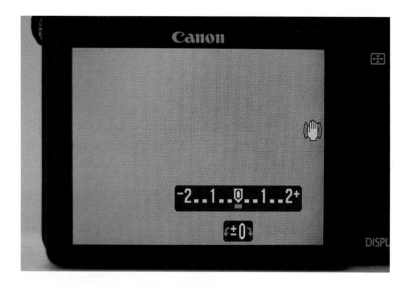

HOT TIP: It may be possible to change the EV setting only when not in auto mode.

HOT TIP: Using combinations of ISO and EV provides many subtleties of brightness.

Setting the focus

In auto mode focusing is done by the camera. In program mode the focus is still handled by the camera but you can change how the focus is applied. Typically there are two options for the auto focus:

- multi AF – the camera determines the best focus based on sampling throughout the image area
- centre AF – the camera focuses on the subject in the centre.

Many cameras have additional focus settings. These are not 'auto' settings but rather fixed settings for certain distances, such as 0.5m, 1.0m, 3.0m, and so on up to an infinity setting. Using these settings allows for creative photography. For example, if a subject is 3 metres away and behind the subject the background is much further, then the subject will be in focus against a soft, unfocused background.

 HOT TIP: It may be possible to change the focus setting only when not in auto mode.

3 Camera accessories and things to carry

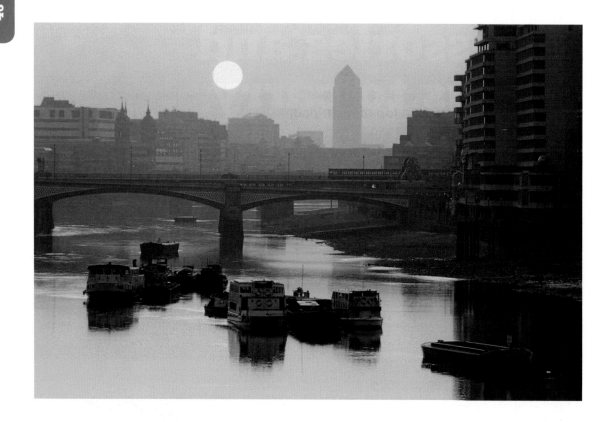

Introduction

Cameras are amazing gadgets. And like most amazing gadgets there are numerous accessories to add to go along for the ride. There are three main accessory categories – protection, better picture taking and taking care of the photographer – yes, that's you. This chapter talks about some obvious camera accessories and also makes you aware of those that can make your photographic expeditions move successful.

Meet the camera's best friend, the tripod

A tripod is a three-legged stand that holds the camera steady. The camera attaches to the tripod on a screw that sticks up from the head of the tripod, and all cameras come with a threaded hole on the bottom where the screw fits in. This creates a secure hold to keep the camera stable on top of the tripod.

The purpose of the tripod is to provide a hands-free way to shoot photographs as what we want is to take photographs with no 'shake' in them. When the shutter is open for

a long enough period, it is difficult to avoid the minute shaking that hand holding will introduce into the picture. At which shutter speed this becomes necessary is not absolute, but certainly anything over 1 second will be hard to keep steady hand-held.

When a camera is on a tripod you can gently press the shutter button and the picture will come out sharp even with a slow shutter. To be even more careful, you can use the camera's timer. Then when you press the shutter button, any slight movement from impact will subside before the picture is taken.

There are various handles, clasps or wing nut tighteners on the head and legs of a tripod that provide all the flexibility to set the tripod to a certain height and angle.

The table tripod

Perhaps you need a tripod for long exposure shots, but don't need one that is as big as you are. You might be taking pictures of a small item – one that is a metre or less in length. You can get up close to the item with a table tripod.

 HOT TIP: Don't immediately let go of your camera after you attach a table tripod! These small tripods can easily tip over if the camera is too heavy. Slowly take your hands off the camera and be ready to catch it if the tripod tips.

 DID YOU KNOW?
A table tripod is ideal for macro shots – getting very close to the subject.

The flexible tripod

Here is a tripod that you can literally wrap around anything that the legs will fit through and let your camera hang in whatever odd angle it needs to. The legs of a flexible tripod can bend and secure the camera in endless places.

1 Attach the camera to the tripod first.

2 Wrap the legs around whatever item you wish to secure the camera onto. You can even shoot with the camera upside down.

? DID YOU KNOW?

Flexible tripods are available in different sizes. Ones with longer legs have more options, such as wrapping the legs around a tree branch or a fence.

The monopod

The monopod is yet another variation of the tripod. As its name indicates it is has one leg (mono) and looks similar to a pogo stick. The monopod, for obvious reasons, cannot stand on its own. It offers a steady alternative to just holding the camera. You attach the camera to the monopod and as the monopod leg touches the ground, the support you have in holding the camera steady is enhanced. This is not a replacement for a tripod but rather a simpler go-between for taking steady shots.

 HOT TIP: An advantage of the monopod is that it is smaller than a tripod and therefore easier to carry around. If you are taking pictures when there is a fair amount of light, a monopod will suffice as the shots you take will not need a slow shutter speed.

The quick release tripod mount

Nearly all tripods come with a removable head mount. The mount contains the screw post that the camera is twisted onto. It fits on the tripod head via a quick attach and release switch. The advantage of this arrangement is that the mount remains fixed to the camera and therefore the camera can be put on and taken off the tripod quickly and easily. Otherwise you would need to screw the camera onto the tripod every time you want to use it.

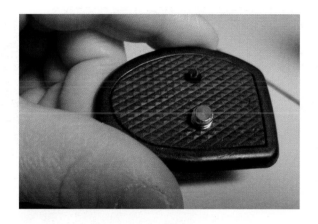

HOT TIP: You should be able to buy extra mounts. If you have more than one camera, attach a mount to each and you can quickly change whichever camera is on the tripod.

The camera case

This is a necessity. Cameras are delicate and one accidental drop could be the end of the camera. Compared with the price of a camera, a bag or case is not that much. There are many types of bags and cases. Some fit the camera like a glove with no space to squeeze in anything else. Larger camera cases come with oodles of pockets and storage areas. An ample case can carry the camera, a couple of lenses if you have them, batteries, memory cards and even lunch. No kidding! Others come as backpacks, useful if you are hiking or cycling for example.

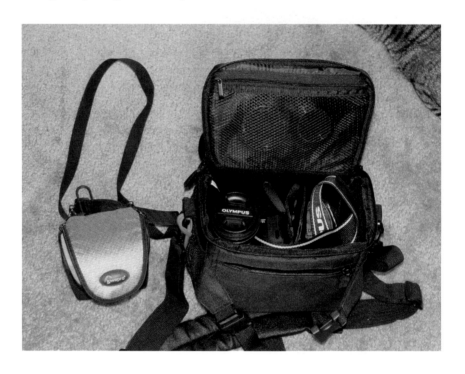

HOT TIP: The camera case is an important part of your equipment. Get a good one with sufficient padding and a sturdy strap.

A hood for the lens

Not all digital cameras have the threading to put on a lens hood. But if yours does, it's a great thing to have. The number one advantage is blocking out sunlight when taking outdoor shots. The number two advantage is it protects the lens. That should be enough reasons for starters.

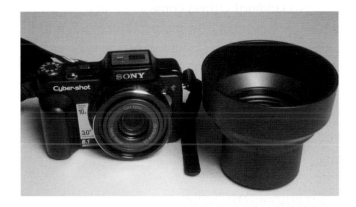

HOT TIP: Look at where the flash is on your camera and judge if the lens hood will block some of the flash. Whereas the lens hood is a boon for the sun, it is a no-no for flash on most cameras.

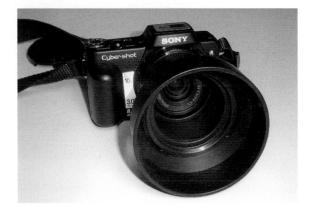

Batteries – don't leave home without them

If there is one universal truth in digital photography it is this – your battery power will run out just when you need most. Why? Because you won't know the batteries are out until you go to take a picture.

Well, this is not entirely true. Cameras have indicators of how much battery juice is left. But just like you would never get stuck in your car having run out of petrol, keep an eye on the battery indicator! And take extra batteries. Because as much as you think you will only take 50 shots and the batteries are good for 80, you will end up needing 100 shots and the batteries were only good for 60. It happens.

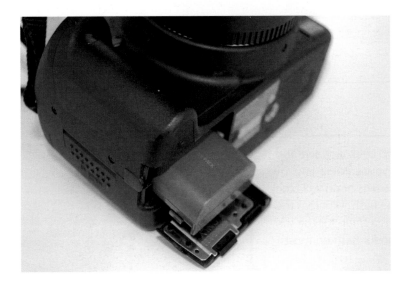

 HOT TIP: Refer to your user manual to learn how many pictures a charged battery can take and to see how much charge is left.

The battery charger

Rechargeable batteries need a – what? A charger! You can have more than one and that might be a good idea if you travel between two destinations often. Leave a charger in each place. Otherwise bring your charger with you – especially on holiday. Just imagine not taking any shots of your trip. Why suffer the embarrassment? If it helps, tape a note to your camera bag as a reminder to bring the charger.

1 Place the battery (or batteries) into the battery charger.

2 Plug the charger into an electrical outlet.

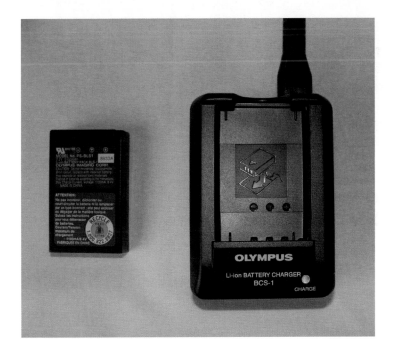

Extra memory

Although one decent-size memory card can hold more photographs than anyone will care to see, carry around extra memory anyway. You may have forgotten to clear off the memory card and it has all the shots of your cousin's wedding. Now what? You can't delete those!

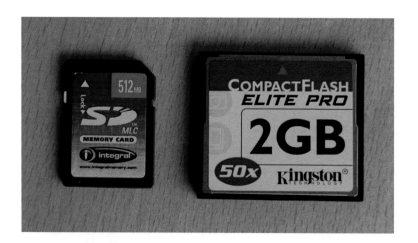

 DID YOU KNOW?

All digital cameras provide a readout of how many pictures have been taken and/or how many pictures can still be taken. Refer to your user manual to gain this information.

Lens cleaning cloth

The last thing you need is dust, dirt or smudges appearing on your photographs from shooting through a dirty lens. Special micro-fibre cleaning cloth is available at camera shops, online shops and other outlets as well. These will do a good job clearing the way for great photographs.

To clean the lens:

1 Gently wipe the lens with the lens cleaning cloth.

1

! ALERT: Check your user manual for the manufacturer's recommendation of how to clean the lens. The technique might be something other than using a micro-fibre cloth.

USB cables

Nearly all cameras connect to a computer through a USB cable and your camera probably came with one. There are many types and sizes available in any electronics store and you should be able to find an extra one to keep in your camera bag. This way you can always download onto someone else's computer if you need to.

1 Plug one end of the USB cable into the camera. Refer to your user manual for instructions.

2 Plug the other end of the USB cable into the computer.

3 Turn the camera on. The computer will recognise that a camera/memory card is attached to it. At this point any number of actions may occur – such as the start of an automated download of the files into your computer. What does happen is dependent on the computer and/or any software in the computer that manages image files. Refer to the computer's user manual or refer to the instructions of the software that runs when a camera is attached to the computer.

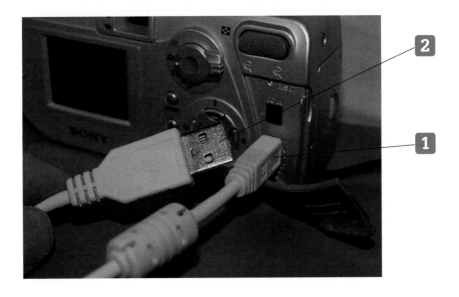

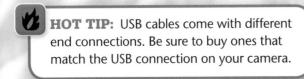

HOT TIP: USB cables come with different end connections. Be sure to buy ones that match the USB connection on your camera.

Card readers

Card readers provide an easy way to get your photographs into your computer or other peripherals. A card reader removes the need to connect the camera to the computer. Instead, you take the card out of the camera, pop it into the reader, and the reader connects to the computer. Although this sounds like the same approach as just hooking up the camera, think of situations when you have multiple memory cards. Having a card reader lets you skip inserting a card into the camera just to see what is on it.

1 Attach the card reader to the computer using the supplied USB cable.

2 Insert the memory card into the card reader.

3 Follow the instructions that appear on the computer screen.

Permission forms

Permission forms? Yes, if you do get serious about photography and take pictures of people, their children, their pets or their property, you might need their permission to use the images. This is not legal advice here, this is common sense. Cover your bases. Do an internet search for photography permission forms. Ask a lawyer. Check with other photographers in your area.

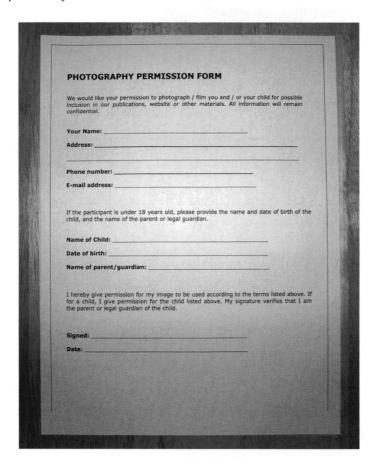

 HOT TIP: Look into the 'fair use' of photographs. It might be allowable to take photographs that pertain to news items or celebrities without permission but find out before taking the photographs.

4 Taking digital shots

Introduction

With a digital camera in hand, the world is yours to capture, well visually anyway. Be generous with taking shots. Get to know your camera inside out. At least know from touch where the shutter button is without looking at the camera. Like a touch typist, knowing where to put your finger without losing sight of the subject in front of you will help you get that candid shot, that unforgettable moment or that quick action scene.

Photography is fun and should be so for you. Since you can shoot literally hundreds of shots in a few minutes, it's not difficult to get the best shot from a set of many that you took of the same subject. In other words, shoot, shoot, shoot! This chapter is the nuts and bolts of how to approach taking pictures – with regards how to set up to get those great shots. The next chapter on composition tells you about taking good shots to arrangement and perspective.

Shoot, shoot, shoot!

Don't think, just shoot. Ask questions later. I know, it sounds like a crime drama on the telly. However shooting a lot and not caring how many shots you take is the best way to get a shot that you might otherwise miss. You have a memory card in the camera. You have your extra batteries, I hope. So take advantage and just keep clicking away. That is how I caught this goose in the middle of a dive for his supper.

1 Keep your finger on the shutter button and press it repeatedly.

2 Depending on the camera, the place (indoors/outdoors) and whether flash is being used, there could be a delay of a second or two until the camera is ready to take the next photograph. So just keep pressing the shutter until the camera is ready.

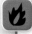 **HOT TIP:** Better yet – have two cameras with you and take shots through each of the same scenes. The results will likely vary as each camera is a bit unique.

Shoot in burst (continuous) mode

Most digital cameras have a setting that will have the camera click away, shot after shot, while the shutter button is pressed. This is called burst mode by some manufacturers, continuous mode by others, and perhaps something else on your camera. Burst mode is something you can practically just leave on all the time because it is in your control to stop the sequence of shots by letting go of the shutter button.

1 Set the camera in burst mode – check your user manual on how to do this.

2 Keep your finger pressed down on the shutter button.

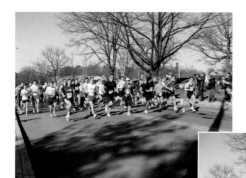

HOT TIP: When using a sequence of burst mode pictures to create a collage, consider leaving some out. For example use every other shot in the sequence. That is how the above collage was put together.

? DID YOU KNOW?
The speed at which burst mode operates can differ between camera models. You might get three shots per second, five shots per second or some other interval.

Use the zoom, but don't overdo it

The ability to zoom in on a subject or scene is readily available on nearly all digital cameras. Like all special treatments, zoom has its use and overuse. Zooming in is needed only when you are too far to frame the scene with the standard non-zoomed setting, or when something undesirable is in the periphery of the scene.

It might be rubbish, glare, unexpected people or other extraneous elements on the sides or top or bottom of the viewing area that have to be taken out of the shot. Another issue is if there is just too much surrounding area compared with the size of the subject in the middle of the scene. Use the zoom just enough to have these distractions disappear from the edges. As you zoom in the imagery along the edges gets pushed out of the viewable area.

1 Zoom in to the full extent.

2 Slowly zoom back out until there is a good balance of the subject and the surrounding area.

 HOT TIP: Pushing the zoom to the max may make the picture fuzzy. Zoom three quarters, and if need be, walk in a few steps.

Shoot across, not down

The angle at which you shoot a photograph affects the intimacy a viewer might feel with the subject. Shooting down at subjects or scenes that are lower to the ground than where you are holding the camera can make the subjects seem distant, figuratively and literally. So if you can, get at the same level as the subject.

1 Be creative with how to get to the same level with the subject. If the subject is higher up than you can reach, look for a chair or stool to stand on.

2 Another technique is to attach the camera to a tripod but don't fully extend or open the legs of the tripod. Use it more like a pole. Put the camera on a self timer setting, press the shutter then hold the camera to the level you need by holding the tripod in the necessary position. Be careful you don't knock the camera!

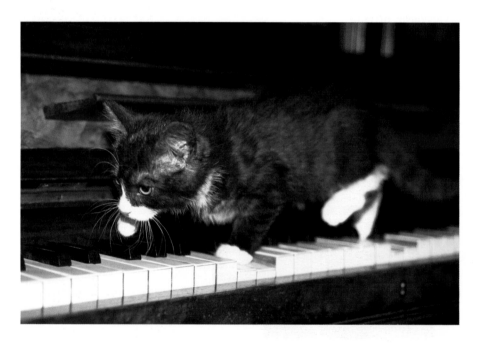

 HOT TIP: If you want to be as one with your subjects, meet them on their terms. Take pictures in the rain – expect to get wet. Take pictures of your cat – expect to be on the floor.

Shoot down when it makes sense

Some scenes need to be shot at an angle either for an artistic effect, or because there is no other way to take the shot. In this case using the zoom feature is helpful when the subject is far down, such as viewing a show or sports event from seats that are higher up than the action.

Many interesting photographs are possible when shooting down is done purposefully for the effect. It often turns out that these are scenes that you have pictured in your mind's eye and turned into a photograph.

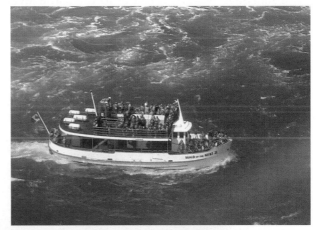

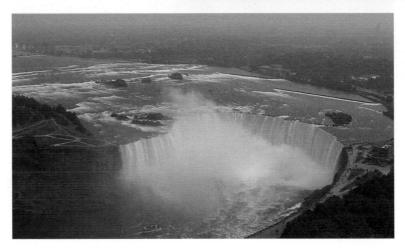

 HOT TIP: When composing a scene that uses an unusual angle the advice to zoom in to remove extraneous elements from the sides can work against you. In these photographs you need something in the photograph to show some sense of the angle. Otherwise it might be difficult to tell if the shot was taken looking down or looking straight ahead.

Tips for shooting up

Taking a shot that looks up follows the same concepts as shooting down. You will be shooting up at a subject simply because it us above you or for a purposeful effect. Trees, mountains, skylines, buildings and large indoor spaces all offer a scene that is above where you are standing, so pointing the camera up is required. When shooting upwards outdoors you must contend with the sun's location. Shooting at the sun (other than sunrise or sunset) is not a good idea. Instead, see if the sky's light itself is not a hindrance. If not, take the shot!

On the creative side, shooting upwards can take a distorted view and make something interesting of it. This effect can be achieved by shooting at an angle. Here, the angle at which the top of the church is positioned, along with the angle of the back part of the building, creates a great shot of opposing angles. The contrast of the shadows and bright areas adds to the mystique.

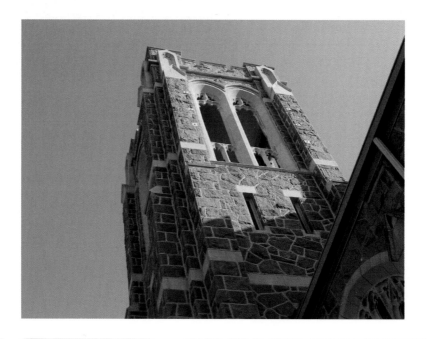

 SEE ALSO: Working with the sky's light is discussed in Chapter 6.

 SEE ALSO: Using angles in scene composition in Chapter 5.

Review as you shoot

If your pace of picture taking is unhurried you can review each photograph as you take it. Your camera has a setting for engaging its review mode. This allows you to look at the shots that have been taken. You can move forward and back through the stored photos, zoom in on them, and so forth. Using the review feature lets you decide if you have taken the best shot or you should shoot some more of the scene in question. Just don't forget to set the camera back to its live setting!

1. Refer to your user manual for instructions on how to enter the review mode of your camera.

2. Cycle through the images one by one or page by page, according to your user manual instructions.

Erase as you shoot

Not only can you review the photographs you have taken, you can also delete them as you go. Check your user manual to see how this is done with your camera.

 Refer to your user manual for instructions on how to delete images from the camera. Usually you have a choice to delete single images, or to delete all images at once.

2 Avoid haste. Be sure the photographs you intend to delete are not needed or have already been saved elsewhere, such as on your computer.

? DID YOU KNOW?
Most cameras provide a choice to delete a single photograph or to delete all the photographs at once.

 HOT TIP: Remember, you don't have to delete anything directly using the camera's controls and menu system. Photographs are stored on the memory card and are deleted from the card, not the camera. You can delete the photographs while the camera is hooked up to your computer – the computer shows what is on the card, even while the card is in the camera.

Bracketing

In auto mode the camera calculates the best exposure (aperture and shutter speed) based on what it senses. The produced photo may not appear as you expect. The camera uses internal algorithms to set the exposure value whereas a person makes a subjective decision. So, to make up for this, many cameras come with a bracketing function.

Bracketing is the process of taking a group of shots in which an aspect of the exposure is changed in each shot. From the base photograph, the exposure is increased and decreased for the successive shots – therefore the original is 'bracketed'. If your camera has an auto bracketing feature, then when you press the shutter button three photographs are taken in succession. You then get to make the choice that suits you best.

1 Check your user manual for how to set the bracketing feature.

2 Experiment in different situations – a bright day, a cloudy day, a scene with light and shadows, and so on.

These three shots were produced in one press of the shutter. The camera quickly shot all three and the exposure differs in each. In the three photographs the aperture maintained a setting of f/8.0. From left to right the shutter speed differs: 1/50 of a second; 1/40 of a second; and 1/30 of a second. As the shutter speed slows down (left to right), the amount of light hitting the camera sensor increases – there is more time for the light to be absorbed. Therefore the effect is one of increasing brightness, left to right. Which one is best? That is for you to decide.

 HOT TIP: If your camera does not have an auto bracketing feature, then you can manually bracket by adjusting the exposure value from the menu settings of the camera.

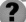 **DID YOU KNOW?** Bracketing is especially useful in situations where there is an uneven spread of brightness. For example, one or more bright areas in the midst of a dark background can confuse the camera as to how to set the exposure.

Check the weather

If you are going on an outdoor shooting jaunt, knowing the weather forecast is a good idea, but perhaps for a different reason than you might think. Clouds, storms and wind provide exciting opportunities to catch dramatic scenes. In a high wind, catching the blowing of leaves or the bending of tree branches provides a dramatic sense of motion and power. Catch a torrential rainstorm – by sitting in your car and shooting through the window. The camera stays dry, and what would normally seem a distraction – windscreen glass in the way of the scene – can be a plus as again it adds to the story: it was so bad out it was safer to be in the car! And if you're lucky you'll catch a rainbow at the end.

? DID YOU KNOW?

The aftermath of a strong storm provides many photographic opportunities – downed trees, snow-covered cars, ice, whatever else comes your way. It's not always pleasant, but it is dramatic.

Shoot the info board

When visiting a new park, or on a trip or holiday, make a note of where you took your photographs. You may not think this is important at the time, but imagine someone asking the name of the park where you got that great shot – and you can't remember. There is an easy way to note this. While shooting pictures, take a picture of the information board, welcome sign, street corner name or some other identifiable marker. This sign reminds me where I took the great shot of the geese shown at the beginning of the chapter.

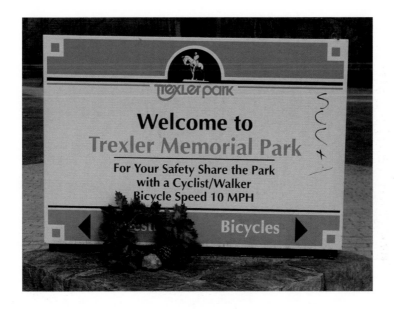

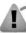 **ALERT:** Be careful in a busy park! Although this sign says bicyclists must go 10 miles per hour, hardly any bicyclists followed the rules. Being in the middle of this with my eyes glued to the camera, I was nearly knocked over a few times!

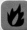 **HOT TIP:** Don't limit your photographs to the obvious. If you later organise photographs into an album, an identifying shot like this is great to include.

5 Composition: the 'art' of photography

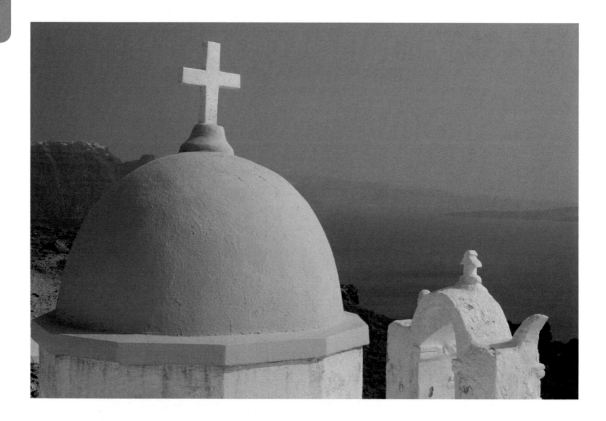

Introduction

What makes a good picture good? Is it colour, space, portraits, candid shots, unusual scenes? It's all of these! But that is not the entire story. Since photography is an art form, the basics of art composition, scale and perspective apply. Not always, as there are times when you just have to start shooting to capture a fleeting moment. But when rushing through is not an issue, the techniques in this chapter elevate the mechanics of taking photographs into the lofty world of creativity.

Sense of scale

It's natural for our eyes and mind to seek references in an image. If you view a picture of a person in a photograph, with nothing else in the picture, you cannot tell the height of the person. There is nothing to gauge height against. Once another object is in the scene – another person, furniture, a tree, a car – really anything – then the height of the person can be deduced. Perhaps not with complete accuracy, but certainly with two people in a scene you can see their relative heights.

 HOT TIP: Sense of scale sometimes only shows relative size difference without a sure way to gauge actual size. In this photograph, it's the bricks that help understand the real heights. The gentleman on the left is quite tall – about 2 meters.

Symmetry

Symmetry can ran the gamut from being perfect, as if a mirror image was set next to an original one, or be approximate and still achieve a rewarding image. It's extremely difficult to find perfect symmetry in nature, and there is no need to as inexact symmetry is the point of a scene being 'natural'.

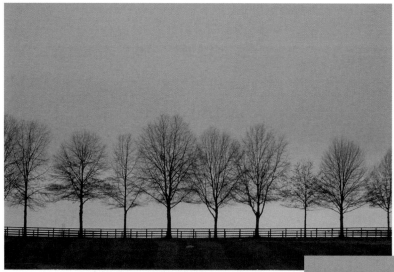

? DID YOU KNOW?

Symmetry effects can be 'created' in a photo editing program. Popular software programs for photo editing are looked at in Chapter 12.

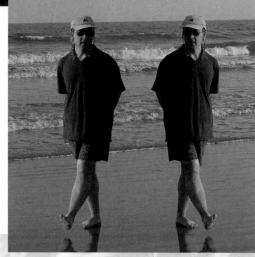

Angles

Lines within a photograph draw your eyes along their path. Lines that form angles provide a bit of visual drama. This can be subtle. In other words, the point of composing a picture with various angles is that angles seem natural, not forced. In this picture the angle of the guitar neck heads in the opposite direction to the slant of the musician's body. There is opposition here, yet it feels correct as this is a natural angle for a musician to hold a guitar.

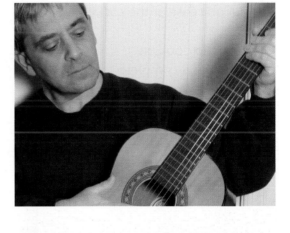

When there are many angles in the scene, having at least one piece stand out gives the eyes a place to get started. This is a close-up photograph of shredded paper. The one piece of shredding in the middle with the bold type grabs your attention. The rest of the shredding – and the corresponding angles – are merely supportive.

1. Looking for angles to have in the scene is a creative process. Take your time to look at the best position to shoot the photograph to include angles.

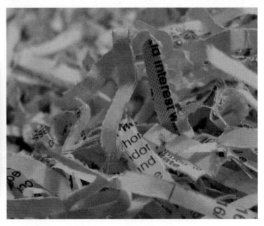

? DID YOU KNOW?

Where do your eyes go? A few I have asked this of note that the eyes travel straight up the guitar neck, then pop over to the face. There is no lesson in this, just something to notice. The brightness of the guitar grabs the eyes first.

🔥 HOT TIP: An attention grabbing item, or defining point, is needed in a jumble of angles such as in the above photograph. If the one strong shredded piece were not in the picture, the focus would be lost and the photograph would be less appealing.

? DID YOU KNOW?

Close-up (macro) photography is a great technique for creating amazing shots. Macro photography is discussed in Chapter 11.

Perspective

With a scene that has some depth (distance) to it, try to get the perspective view in the photograph. Perspective is like another type of angle treatment, but it is natural. Not all long-distance scenes will show perspective. For example you might be standing 30 metres away from a large wall. A head-on photograph of the wall won't show perspective as the entire area is flat. And that's OK as that is how a wall looks. However, if the scene in front of you offers perspective, see if you can position yourself better to get a good sense of the converging angles.

Of course no book on photography is complete without the standard perspective photograph – of train tracks merging together in the distance…

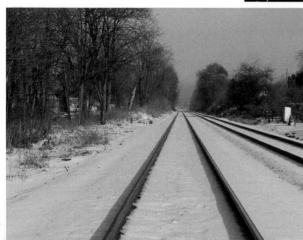

 HOT TIP: A scene with a long range of distance is best to show perspective. Excessive zoom will shorten the range, so ease off the zoom to get perspective in the scene.

Have fun with colour

You occasionally get scenes of mulitple colours in nature – autumn leaves or a peacock's feathers come to mind – but when your creative juices take over the sky's the limit.

This portrays an interesting approach to the 'art' side of photography. Take an item or items away from their intended purpose and set up an interesting arrangement. Since this is about colour, I took paint brushes and instead of using them to paint something with colour, I took a photograph of the paint brushes themselves.

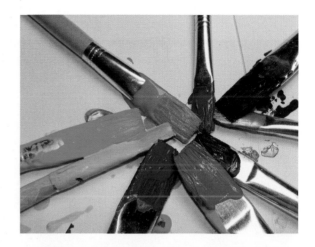

Out-of-doors colourful scenes are often provided by man-made objects. This is a shot of a cinema that is very attractive and attention grabbing. The shot was taken at night – when the lights are on and the sky is dark; this provides great contrast to make the lights stand out.

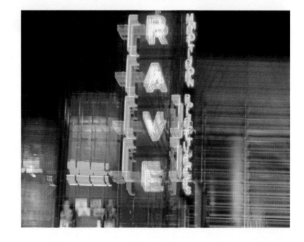

 HOT TIP: Night photography offers fascinating opportunities. The above picture was purposely made blurry for the effect. The shutter speed was slow – about 1 second. Turning the camera slightly while the shutter was opened created the blurred effect.

 HOT TIP: If you are working with something messy like paint, keep your camera on a tripod and out of the way!

Contrast within an image

In imagery contrast is the difference between opposing elements such as colour or light. Creating directed light with lights and boxes is one thing, but finding natural settings with directed light is quite another. Clearly a place where sunlight can be funnelled is needed for natural contrast, at least to be striking.

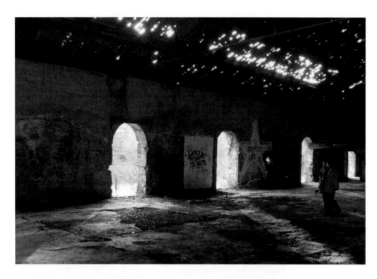

 HOT TIP: Big light, small opening – put them together and the light should stream through the opening.

Colour contrast can be striking. There is a reason a rainbow is appealing as one colour flows into the next. If a rainbow is not to hand, then take the next best thing: shoot a man-made object that is purposely full of colour.

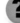 **DID YOU KNOW?**
There is a place where you can always see rainbows. It's Niagara Falls, which straddles the United States and Canadian border. An incredible amount of mist is produced from the Falls and rainbows constantly appear above the water.

Capture emotion

People are often asked to smile when their picture is taken. Why not try asking them to show a different emotion instead. Encourage your subject to let it all out. Having a bad day – show it!

1 Show people how they are really feeling. Always asking someone to smile is a fake effort.

2 Shoot as people look at you, and with enough shots you will capture their true feeling. Like any art form, photography is meant to capture the range of emotions.

 HOT TIP: Show people as they are and what they feel. This realism will create outstanding portraits. Tears, joy, sorrow, wonderment; it's all there to use. Make the best of it.

Capture the reaction, not the action

In the face of doom, entertainment or something unexpected, it's our nature to point our cameras to the source of the attention. Just as pertinent a story can be found by the expressions on people's faces as they view the attention grabber.

1 Attend a sports event or performance where photography is allowed and at which you are able to walk around.

2 Try to position yourself where you can face the audience and take photographs of people watching the entertainment.

3 It's best to do this from a distance using zoom, so the subjects remain candid and unaware of being photographed.

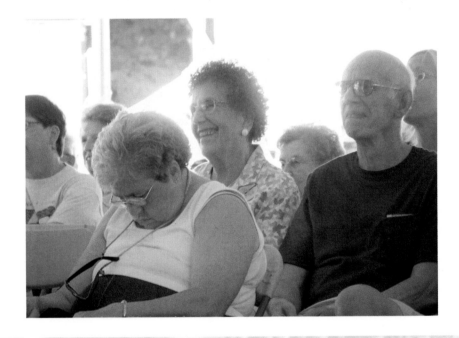

 HOT TIP: People have a range of reactions. Here some are excited and one has simply fallen asleep!

Leave the tale unfinished

A photograph can tell a story, and the story can be unfinished. The imagination can make what it will of the tale. You set the scene and reactions will vary.

1 Look for a scene that made you question what had occurred or is about to occur.

2 This is a creative, subjective process. A bit of wonderment in your photographs will entice viewers to have a reaction, which in fact you can then capture in a photograph.

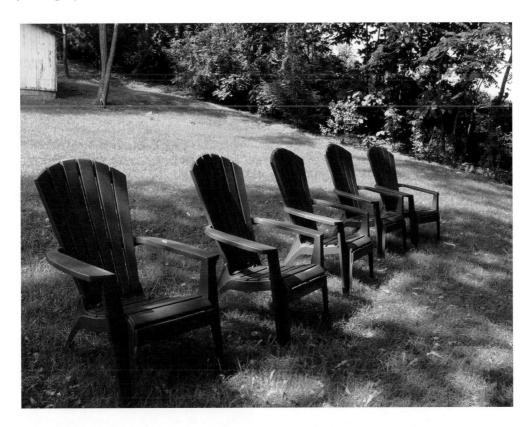

? DID YOU KNOW?

This scene makes one wonder why these chairs are lined up this way. What are people about to watch, or perhaps, what did they watch? Note how the chairs are strategically placed in the shade, clearly put there to keep the viewers out of the bright sunlight.

The rule of thirds

A standard composition technique is to use the rule of thirds. When setting a scene, place the subject along an imaginary line or point that is one-third to the left or right, and/or one-third towards the top or bottom.

This photograph places the centre of the balloons along the left and bottom thirds. With guidelines placed over the image it's easier to see how the subject is placed within the scene.

1. When you are ready to take a photograph of an interesting subject, aim the camera so that the subject is off centre.

2. Depending on the actual scene there may be more than one subject or part of the scene to place along a 'rule of thirds' line, such as placing the horizon lower or higher.

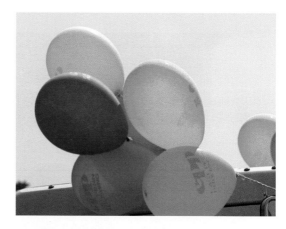

? DID YOU KNOW?

The rule of thirds is similar to another visual guideline – the golden proportion used by artists. Whilst hard to explain in a sentence or two, the main idea is that any image that is to be split has a sweet spot that is not in the middle, but rather near the two-thirds point.

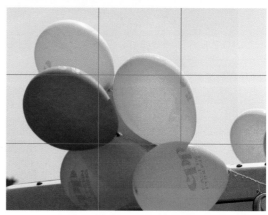

? DID YOU KNOW?

Fibonacci was an Italian mathematician who lived in the twelfth century. His number sequence (the Fibonacci sequence) shows a relation between mathematics and patterns occurring in the natural world. It's all fascinating and worth a read on the road to good photography.

Get blurry

Blurring the motion of a moving object in a photograph adds to the impact of the imagery. Motion can be showed in three ways. One is to capture the subject in sharp detail while the background blurs. The other is the opposite – capture the subject as it moves against a static background. The last technique, and possibly the one with the greatest opportunity for impressive shots, is to move the camera along with the moving subject. This is known as 'panning'. A photograph can be quite artistic using this technique, even to the point of not being sure if the subject is what you think. But for clarity, here is a panned shot of a car.

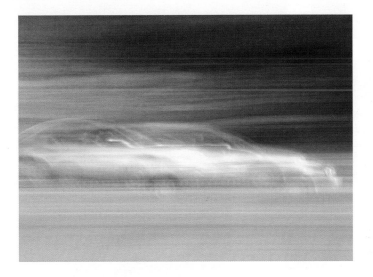

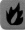 **HOT TIP:** Panning is dependent on the shutter speed. You move the camera along with the subject, but obviously the panning stops when the shutter closes. If your camera has a manual mode or a shutter priority mode, try various shutter speeds.

6 Lenses and light

Introduction

The mechanics of translating an image from the real world into a flat representation are technical, but you don't need to know every detail. What is important, or at least helpful, is to understand exposure. Exposure is the combination of aperture and shutter speed. Exposure settings tell the camera how to handle the light hitting the internal camera sensor.

Aperture and shutter speed

The shutter is like a door – it opens and closes – but is round. The normal state is for it to be closed. It opens when you press the shutter button to take a picture. The aperture setting is how large (not how long) the shutter will open. Thinking of the door, you can open one all the way, or just a bit, or anywhere in between.

Aperture settings are symbolised as f numbers. An aperture setting of 5.6 is written as f/5.6 and is called an f-stop; in this example you would say the f-stop is at 5.6. The lower the number, the wider the opening. Therefore an f-stop of 2.8 is a wider opening than f/11. It might be confusing at first that a higher number is a smaller opening.

Shutter speed is the measure of how long (not how large) the shutter stays open. A picture can be taken extremely fast, such as at 1/2000 of a second. The slowest shutter speed is effectively a shutter that never closes. There is a point when the speed of the shutter is not fast enough to overcome hand shaking. It might seem like you are holding a camera rock solid but just a twitch can make a blurry picture. That's why you stabilise a camera with a tripod or rest it on a surface.

Aperture and shutter speed are inseparable and have an inverse effect. With a fixed aperture, more light will enter the camera with a slow shutter speed – the shutter stays open longer. With a fixed shutter speed, more light will enter the camera with a large aperture. More light can enter through a larger opening. In theory, if you shorten the size of the shutter and increase the speed, a similar result occurs as when you increase the size and decrease the speed.

 HOT TIP: Understanding how aperture and shutter speed affect photographs is core to photography. Even if you never take the camera out of automatic mode, it's still good to know why a photograph turns out the way it does – which is based on the camera deciding the best aperture and shutter speed.

Full automatic

With no intervention on your part, your camera shoots pictures according to internal calculations. When you press the shutter button halfway, the camera sees the scene you are pointing it at and quickly makes adjustments. These include the aperture, shutter speed, focus, whether to use the flash and other settings.

It's automatic – you do nothing expect press the shutter button. This is the easiest way to use your camera and the least flexible approach. This is fine if you do not wish to take the learning curve of camera technicalities. Most people never take their camera off the automatic setting.

1 Place the camera in the auto setting. Check your user manual if necessary.

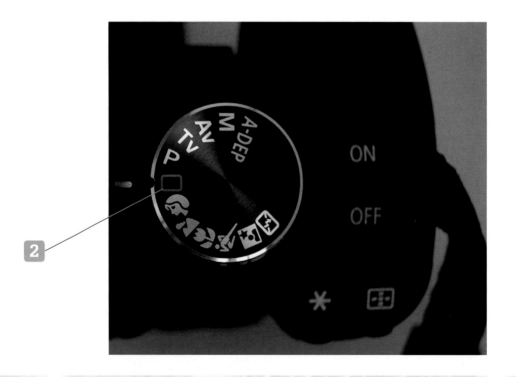

 HOT TIP: Most cameras offer settings beyond automatic. These alternatives are usually found in a ring or some other type of movable selector switch. Common alternative settings are P (Program Mode), M (Manual Mode), A (Aperture Priority), S (Shutter Priority) and then an assortment of presets. These are all discussed in this chapter.

Aperture priority

Aperture priority is a mode in which you decide the aperture (the f-stop), and the camera decides the best shutter speed. This determination is made when you press the shutter button halfway down for the camera to get a reading of what is in the scene.

Aperture settings are intertwined with the depth of field. This means that each f-stop has a range of area (in feet, metres, etc.) in which items will be in focus. Large aperture settings (low f numbers) have a shorter field depth, and the smaller the opening, the longer the range of what is in focus. Applying a purposeful aperture setting can result in a beautiful photograph. This photograph was shot at f/4.4. The berries are in focus and anything that would have been nearby would also be in focus. However the background is much further away than the berries, and therefore it's blurred.

In contrast, here is a scene that has the entire long street in focus. The aperture is f/22, which is a quite a small opening.

 DID YOU KNOW?

As a shutter opening gets smaller, the depth of field approaches infinity. 'Pinhole' photography is a specialised method that has a scene reach film literally through a hole made with a pin. The images created with this method are unique and can be quite spectacular.

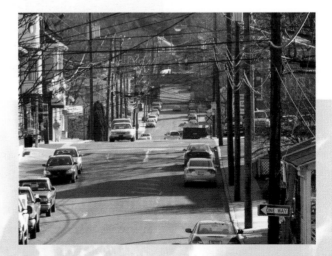

A comparison of aperture settings

To demonstrate how aperture settings portray a scene, I constructed a set of photographs that contain a close up item against an expansive background. The camera was focused on the bicycle. The three shots were made with different aperture settings: 4.5, 8 and 22 – from top to bottom. The bicycle stays in focus and the background goes from blurred in the top image, to clear in the bottom image.

Shutter priority

When a camera is on shutter priority, you select the shutter speed and the camera determines the best aperture. This is useful when you need to consider subjects in motion. To capture a vehicle or sports activity without blur, the shutter needs to be fast. Useful speeds for action are 1/125 of a second or faster. The speed of the active subject will help make you decide on the shutter speed. A racing car is much faster than a runner. Also distance from the subject will have an influence. The further you are from a moving subject, the slower it appears to move relative to you.

1 Place the camera in the shutter priority setting. Check your user manual if necessary.

2 Try taking photographs at different shutter speeds and see how they turn out. Notice how shots taken at slower speeds are brighter and can also be blurry from hand shaking. Use a tripod to avoid this.

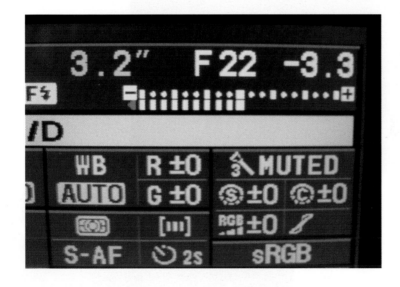

 HOT TIP: If it seems difficult to determine a shutter manually, then don't. Full auto will be fine in nearly all situations. Many cameras also have a preset for sports photography.

A comparison of shutter speeds

To demonstrate how different shutter speeds affect the light coming into the camera, I took a series of shots of candles in a decorative holder sitting on a table. The aperture remained fixed at f/4.6 and the ISO remained fixed at 200. No flash was used. The room was very dark. The scene was shot with speeds of 1/60 of a second, 1/30 of a second, 1/8 of a second, 1/4 of a second, 1/2 of a second, 1 second, 2 seconds and 4 seconds. At the fastest speed it is difficult to tell anything about the image. By the time the slowest speed is used, the detailed work of the holder, the shape of the table, and even some items in the room are visible.

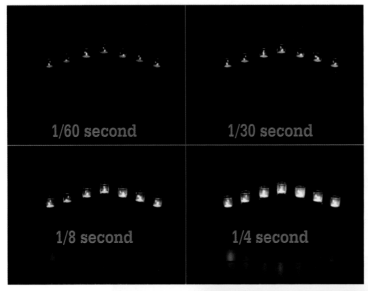

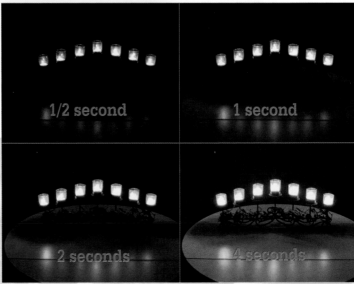

Program mode and manual mode

Program mode is a step away from full auto mode. With program mode the camera still determines the exposure – the aperture and shutter speed. Other settings become adjustable such as how the focusing should work and the ISO speed of the sensor.

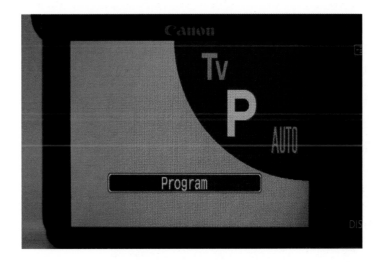

Manual mode gives you full control of the camera. You can set everything but with that comes the need to know what to set! Unless you are an old hand at photography, try aperture priority, shutter priority or program mode to ease into using some manual settings.

1 Place the camera in either program mode or manual mode. Check your user manual if necessary. Not all cameras have a manual mode.

2 Use program mode to become familiar with camera settings other than aperture and shutter speed. In program mode these are set by the camera.

 HOT TIP: Check your user manual to see what is the longest available shutter speed. Higher-end cameras may have something known as bulb (a leftover term from days of film), which lets the shutter stay open indefinitely. This is especially useful for night photography. See Chapter 11.

 HOT TIP: Use aperture priority and shutter priority to become familiar with exposure settings. Then use program mode to become familiar with other settings.

Presets

On the settings dial you will probably see some presets, indicated by symbols, and there may be a scene setting. If scene setting is available you should be able access more presets somewhere within the camera's menu system. There is no magic about the presets. What they do is set exposure, ISO and/or other settings to accommodate the type of photography being sought. For example:

- Action sets a fast shutter speed.

- Landscape sets a high f-stop (a small lens opening) so the range of focus is long in order to capture a large outdoor scene.

- Portrait sets a low f-stop (a large lens opening). The focus is a short range in order to capture the subject and leave the background soft and blurred.

- Twilight sets a slow shutter speed to capture the reduced light.

Each camera has a different mix of presets, and will even name the same ones differently. For example one camera I have has a twilight mode, and another has a sunset mode. They are the same. Here is a photograph I took of a particularly colourful sunset using twilight/sunset.

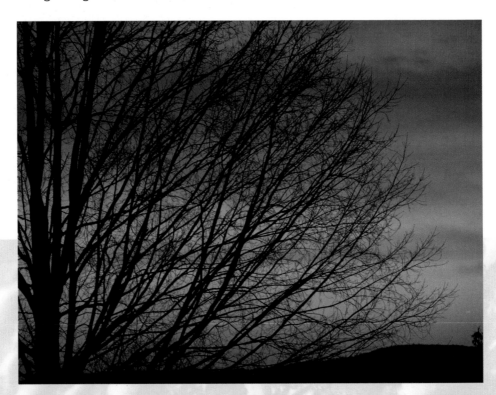

The quality of light

Light has a rating system known as the kelvin temperature scale (named after the British physicist William Kelvin and denoted by the letter K). The scale rates different light sources from the low output of a single candle (rated around 1500K) up to a bright blue sky (around 12,000K). There are various points on the scale for different light sources: for example, an incandescent bulb falls around 2800K.

In photography, a consideration is to balance colour. This does not mean swapping some yellow for green: it's about where light is desired to be on the kelvin scale, and is referred to as white balancing. If you consider the off-colouring of different lights sources – an incandescent bulb gives off a yellow tint; a fluorescent bulb can give off a pink or blue tinge – then the point of white balancing is to neutralise these off-colourings.

All cameras have an auto white balancing feature, and I recommend just leaving it at that. There are some image manipulations to be had if you use the manual colour balance settings. However, it is difficult to provide guidance as every scene is different, and light can change quickly when outdoors.

1 Use the menu system to change the white balance settings. Check your user manual if necessary.

2 Take shots of the same subject in the same lighting, but at different white balance settings. Notice the difference in the photographs?

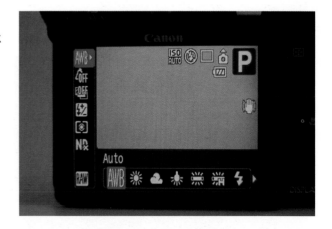

? DID YOU KNOW?

If you are interested, read up on Kelvin. He first derived his scale from observing a burning block of carbon. At different temperatures the carbon emitted different coloured rays of light.

ISO

ISO is a rating of the sensitivity of the camera's sensor to light. This rating has its roots from the days of film when any roll of film was of one ISO value. In the digital realm you can adjust the ISO per shot, which is great improvement from being stuck with one ISO rating through an entire film roll.

ISO is also referred to in terms of speed. That is, a faster ISO means a faster sensitivity – a faster gathering of light. ISO numbers start at 100 and go up in a doubling count. The ISO numbers therefore are 100, 200, 400, 800, 1600, and could be higher depending on camera. ISO can be left on auto and the camera will set it accordingly. Going manual there are guidelines: the lower numbers are used indoors and the higher numbers are for outdoors. This is because, assuming it is brighter outside, the exposure is set with a faster shutter and the sensor has less time to gather the light. However these are loose guidelines. For example, using a slow speed indoors would seem not to make sense, unless you consider that a flash is firing when the picture is taken.

Here are two pictures identical in all settings except the ISO. On the left, the ISO is set at 200. On the right, it's set at 800. Since an ISO of 800 is faster, the image is brighter.

Using flash

It is typical to have four flash settings on a digital camera:

- Auto flash – the camera senses when to use flash.

- No flash – the flash will not fire, regardless of conditions (this is useful in public places where flash may not be allowed).

- Fill flash – the flash will always fire.

- Slow flash – more background elements will appear in the picture.

Slow flash is useful when the background behind the subject is dark but you want it to appear in the photograph. Slow flash works by keeping the shutter open longer than the flash firing. What happens is that the subject gets lit up with the flash, and then the shutter stays open longer so more light can enter the camera. The weak light of the background has time to be picked up by the sensor.

These two photographs, taken at night, illustrate the effect of slow flash. The first photograph was taken with fill flash. The tree and a bit of the background is visible. In the second photograph, taken with slow flash, much more background appears.

 HOT TIP: If you think flash is unnecessary outside, think again. Fill flash is useful out of doors to compensate for shadows. For instance, a person wearing a hat may be bathed in sunlight but their face might be in a shadow caused by the hat's brim. Shooting with flash fills in the shadow.

Auto focus

Auto focus takes the drudgery out of getting the subject in focus just as you are about to take the picture. Auto focus works when you press the shutter halfway down. This lets the camera review what is in front of it and set itself accordingly. This probably includes setting the exposure, ISO, testing whether to use flash, and so on.

The camera sets the focus based on what is in the centre of the scene. After a moment with the shutter button half pressed the camera should give an indication that the picture is ready to be taken. This can be a sound or light indicator appearing in the viewfinder. You press the shutter the rest of the way and the picture is taken.

Yet sometimes a photograph comes out blurry. Here's why. The camera focuses on what is in the centre. But what if your subject is towards the side? If the object in the centre, whatever it might be, is not at the same distance as the subject, then the subject can be blurry. Here is how to work around this problem.

1 Aim the camera on the intended subject.

2 Push the shutter halfway down until it locks onto the subject and has it in focus.

3 Aim the camera in the intended direction, the subject is now on the side of the scene.

4 Push the shutter down and complete taking the picture. The distance at which the camera focused is the distance that the subject is at. The subject remains in focus, even as other elements of the scene possibly do not.

 HOT TIP: The camera can focus on the centre, but that could be the centre along with a larger area. You may be able to see the boundaries of this area in the viewfinder or on the LCD. Your camera may have other focus settings. See if there is a spot focus. This tells the camera to focus on a small section of the centre. This may produce better results, depending on how far the subject is from the camera.

Metering

Metering is the basis of how the camera sets the exposure. Metering can be left alone and will stay on an auto setting. This default is a 'multi-zone' metering. The camera samples a number of smaller areas within the view and takes an average to set the exposure values. Sometime this works against you since there could be a significant contrast in light throughout the scene.

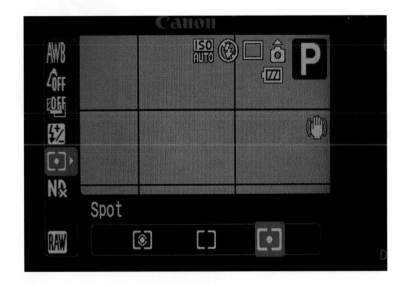

To compensate, most cameras provide two other metering modes. Weighted (or centre weighted) metering still samples the full scene but places a greater weight on what is in the centre. Spot metering samples just the centre. These two alternative methods are handy for when the subject and the background have considerably different light levels.

1 Check your user manual for how to change the metering.

2 Experiment by taking a shot of the same subject with different metering settings.

 HOT TIP: Experiment with the metering modes in your camera. Place a subject against a dark background and try the different settings. Then you will know what setting to use when you want the background to have definition, and when you don't.

Using a filter

A filter is a piece of circular glass held in a metal ring. The ring is sized to fit your camera lens.

The glass is treated to produce certain properties. These might be to alter colour, to distort the view, to enhance contrast, to control brightness, and so on.

One of the most popular filters is the polarising filter. This filter works by readjusting the rays of light coming into the camera. The purpose is to reduce glare. There are other advantages also such as producing a deeper blue sky.

Here are two shots of an object that has reflective glare. The first shot shows what the untreated glare looks like. The second shot was taken using a polarising filter.

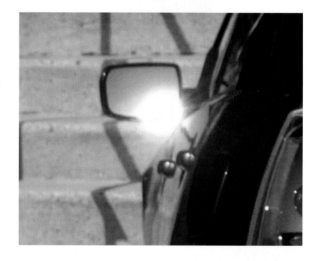

? DID YOU KNOW?
Your camera may not allow filters to be added to the lens. However, you can achieve the same enhancements using photo editing software.

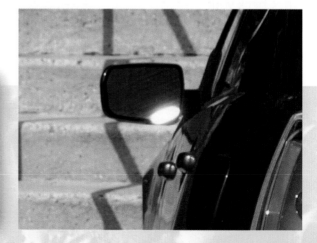

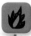

HOT TIP: Leaving a filter permanently on your lens serves to protect the lens from scratches. A scratched filter is less costly to replace than a lens. You can even purchase filters which are nothing but clear glass used solely for the protection of the lens.

Using studio lights

When you are ready to take the leap to the next level of your photographic pursuits, a likely progression is to invest in lighting. Studio lights come in a variety of sizes and strengths. The number of lights you have provides more options for how photographs will turn out.

When one light is used it is best set to one side of the subject. This lightens the subject on the side where the light is and leaves the other half in shadow. This is useful for mood shots and can be dramatic when the camera is set on the black and white setting.

With two studio lights the common setup is one on each side of the subject at roughly a 45 degree angle. This brightens the subject evenly. However a shadow may appear behind the subject. If available, a third light is aimed at the wall or backdrop behind the subject and this removes the shadow.

Studio lighting is an art. Experimentation is necessary to become familiar with the nuance of lighting. Another factor is what is behind the subject. It could be a wall or it could be a backdrop. There are several types of backdrops to put behind a subject. Various materials and colors can be found at any good photography store.

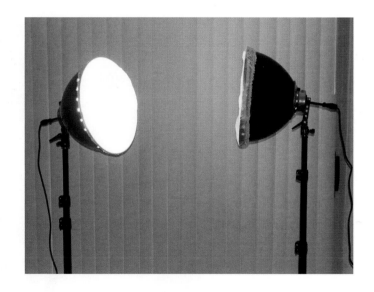

 HOT TIP: Perhaps the least expensive backdrop is a bed sheet. Next up is paper. Well-stocked photography stores should have large rolls of paper for purchase. Note that some are so wide you may need an extra hand putting the paper up.

Portrait photography

When all the preparation is complete, time for the smiles and the shutter clicks. There are various techniques for taking portraits. Being close is essential, but you cannot be so close that you are crowding the subject, nor can you have the camera capturing light hitting it direct from the lights. Put the camera on a tripod and use a little bit of zoom to get close. Any distortion that zoom can make at extremes should not be an issue since you are fairly close.

The rest is all about taking lots of shots. If you got a great shot, don't stop. Keep taking more. Stop whenever the time is up, or a subject is starting to yawn, or when you have had enough action. Don't stop simply because you think you have enough. There always seems to a better picture ready to be taken.

Here are some examples of great portrait shots.

? DID YOU KNOW?
The lighting, subject placement and proximity (how close up the shot is) all affect the outcome. This is harder than you think to get just right.

7 People

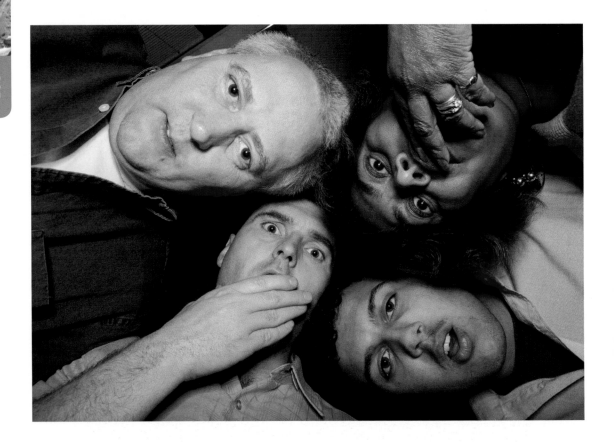

Introduction

People can be so interesting to take pictures of and yet so fickle. For some inexplicable reason, when you're trying to get a group shot someone will sneeze, look away, blink or start talking. In this chapter we give one or two ideas about how to handle all that.

Photographs of people can be categorised in two general ways – posed and candid. Posed shots are great when they turn out they way you expect and frustrating when all that posing leads to a meek and weak image. Digital techniques are discussed elsewhere in this book, notably in Chapter 6. This chapter is about people, and the composition aspect when appropriate. Bear in mind that with candid shots you often don't have any time to think about composition; you have to capture the moment before it is gone.

Finally, people are expressive. Capturing that smile, that curiosity, or that angst or sorrow is what makes the scenes feel alive.

Honour

Humble and dedicated. This retired soldier marches in a local parade but from the look on his face you can see he is lost in the memories of the battles he fought. The saying goes that an old soldier will fade away. Some don't follow that belief, and this gentleman is certainly here and active. I'm sure he carries a lifetime of stories within himself. We won't hear of them, but clearly they are part of him through and through.

1 When viewing a parade, a march, or other activity in which many people participate, look for expressive people.

2 Take shots at various levels of zoom. Get a person's face close up and get some shots zoomed back a bit so more of the person and surrounding is seen.

 HOT TIP: Photographs are moments in time. You can't always wait for the perfect shot. Instead take many shots and review them to find the gem.

Capture surprise

Some special moments happen just as you are shooting away. You can get lucky and capture a look of wonder, oddity or surprise. When a scene like this is staged, it can look real but of course it is planned. Getting the candid unplanned expression is a photographer's dream.

This child looked at the camera and was perplexed to see a photograph being taken of him. His facial expression is a wonderful mix of surprise and somewhere between 'don't take my picture' and 'hmm, someone is taking my picture'.

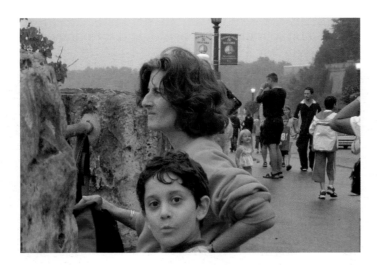

1 A shot like this is often caught because the camera is on burst mode, so set yours as such.

2 Don't wait for a person to make an interesting expression. Instead keep shooting and wait for the person to give an unexpected expression.

3 A useful trick is to make a noise of some sort to attract attention. Try stomping on the ground quickly or something similar.

? **DID YOU KNOW?**

This photograph exceeds on a few key points: the boy's position is spot on using the rule of thirds; the mum is unaware a photo is being taken, yet has an interesting expression of her own; and the various distances to others in the scene, as well as the farther trees in the distance, provide good depth and perspective.

Capture a youngster engrossed in his world

Candid shots of children are one of the gems of photography. Here we see a boy so into his activity that we can imagine that he is thinking only about digging that hole in the sand.

1 Find a child at play in his/her pursuits.

2 Shoot a candid scene that captures the child along with the surroundings.

 HOT TIP: With the camera put on beach setting (this might be called something else on your camera), the contrast between the sand and the pools of water became more distinct. The texture and the shadows accentuate the scene. A picture like this could easily have looked washed out if not enhanced with the camera's helpful settings.

Capture a youngster's joy

Here is another one of those shots that just fell into place in more than one way. Obviously the joy and pride are apparent: no debate about that. In the composition aspect is symmetry. The arms clearly add symmetry, as do the painted cheeks. More subtle though are the two front teeth, the indentation where the boy's Adam's apple is, and perhaps even his eyes.

There is also cohesiveness in the colours. The pink on the back of his left hand (what we see on the right) matches the pink on his right arm. These areas tend to pull the scene a bit tighter as if an invisible string is keeping the two in place.

1 Once a child has created his/her masterpiece, take a shot of the child showing off the artistic results.

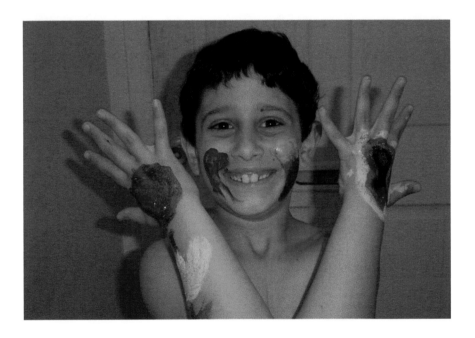

 ALERT: Paint and cameras don't mix! Take a picture like this from a distance.

Young friendship

This photograph is somewhat candid and somewhat posed. It is posed in the sense that the children were asked to give each other a hug. Young children don't have much of an attention span and so the photograph was shot without much 'working up the composition' before the children drifted away. The juice boxes are good props, and the sandal just happened to be there, but with this type of spontaneity you take what you can get.

1 It's always good to have a camera ready to go when around children.

2 Often just shoot, and shoot some more. The beautiful scenes and expressions can come and go quickly. Don't worry about composing the shot. The children get the viewer's focus and that is the point of the photograph.

? DID YOU KNOW?

Children are so photogenic it barely matters how you set up a scene. Getting candid facial expressions makes pictures like this a success.

Using natural elements to frame a scene

In a park, a garden or a forest, the trees, shrubbery and flowers can be put to good use to frame a scene. With a little bit of looking around and perhaps changing the position of yourself in relation to the people you are photographing, it should be fairly easy to find an area to place them.

The frame can be subtle and indeed will not be perfect in dimensions. This is nature after all. In this scene the family blended nicely with the bush on the left and the plants on the right.

1 Find a place where nature's elements form a frame. This can be subtle or just a suggestion of a frame. It all depends on where you are and what natural elements are nearby.

2 To get a usable frame try stepping forward or back as well as looking around. What seems far apart will come closer to the sides of the viewing area as you move back. On the flip side, as you move in, what might look like usable natural elements on the left and right will become more distant.

3 Invite your subjects into the scene and click away!

 HOT TIP: Weather is your friend and your foe. A bright sun is often a no-no for good photos, but on occasion comes to the rescue. By making adjustments of exposure values and/or setting the ISO to a high number, such as 400 or 800, the overly bright sun can be held at bay.

Action photography

By the very nature of it, action shots – sports or otherwise – are candid shots. There is no posing. So follow these rules, which apply to action photography:

- Keep shooting – if it makes sense leave your camera on burst mode (burst mode and the need for flash do not go hand in hand, which is why burst mode is usable only in well lit places).

- Use shutter priority – the key to capturing action is to 'freeze' it. This can happen only with a fast shutter speed. Outdoors, a shutter speed of 1/125 of a second is adequate. A speed of 1/500 or 1/1000 is better still. However, the lighting makes part of the decision for you. Trying to shoot at a very fast speed without ample light will not yield a usable shot. Indoor action photography will probably need a speed that is slower but obviously not so slow that the subject gets blurred.

- Don't wait for a good shot – a good shot will pass you by before you realise you missed it! Take as many shots as you can and review them later.

This photograph was shot with a speed of 1/40 of a second. This is not a particularly fast shutter speed, but on the other hand, bowling is not a particularly fast sport. The important point about this photograph was that flash was necessary. After some trial runs on various manual settings, I had to let the camera make up its own mechanical mind. Normally I would override the settings but in this particular situation I, the photographer, was becoming a nuisance to other bowlers. So there is a rule you should follow – don't be an annoying photographer.

(Special thanks to Elizabeth and Sue)

 HOT TIP: To shoot a fast-moving sport, such as football, rugby or tennis, have more than one camera with you ready to go – with different settings in place. There is no time to fumble around with changing lenses or changing cameras. In sports photography you do not get second chances. Carefully place two cameras around your neck and be ready to switch quickly – with one set for a wide view (to get a team in action) and the other set to a zoomed in view (to get a shot of a single player).

At the parade

A carnival or parade is a great public place to capture many photographs. This local parade had group after group of musicians, miltary veterans, jugglers, antique bicycles and cars, and much more.

This shot is one of the bands that came by. Numerous shots were taken, and this one has elements that make it one of the best. The shot was taken from the vantage point of where the musicians were turning to march down a perpendicular street. This added the contrast that a number of the players are lined up on the left, and the few that are closer to the camera have already made the turn. The focus – in which the closest players are clear and the ones down the line become blurry – tends to exaggerate the length of the line.

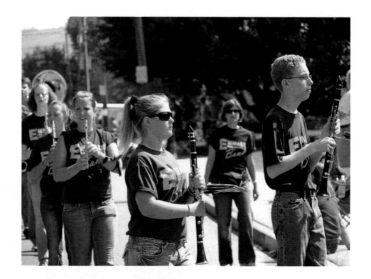

1. Shoot, Shoot, Shoot!

2. Get as close as you can to the action (as much as the supervisors of the parade will let you). Being close lets you avoid shooting everything with an extensive amount of zoom.

HOT TIP: Find a position so the sun is behind or to the side of you. Avoid shooting into the sun.

Using a positional trick

This type of photograph can feed one's ego. The technique here is to position your subject in such a way that they seem to be handling the impossible. This shot did take several attempts to get the pose correct. The scene had to be wide enough to get more than the arch into the visual area.

If you didn't know better you could be fooled into thinking the land bridge is just a fair amount taller than the person, perhaps only 10–15 metres. Actually this is Rainbow Bridge in the western United States. It is the largest land bridge in the world at 76 metres tall and with a span of 73 metres.

? DID YOU KNOW?

Although this is an interesting shot, it lacks a way to gauge the size of the natural land bridge. Clearly the way the scene is composed does not show any true sense of scale.

Outdoor sports

Sports can get people fired up and serious. With some sports it's difficult to get a good shot of the subject's face. In the US, baseball is a top sport and people get serious! Facial expressions are easy to see on baseball players since no guard or helmet is worn.

This pitcher has just sent the baseball flying towards the batter. As any pitcher will, this one is intent on seeing the batter miss hitting the ball.

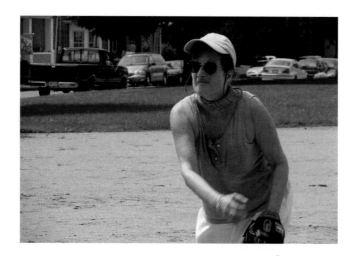

Although sports photography is meant to be shot with a fast shutter, this scene is interesting in that the pitcher's hand is a bit blurred from the fast-throwing motion. That's okay, a sense of motion adds to the drama.

1 Sports photography is fast; not just the shutter speed but your reaction as the photographer. Be ready to shoot at the moment of movement on the part of the sports player.

2 Try to get the player's expression but also include enough of the body to tell what sport is being played and hopefully catch some motion.

HOT TIP: When I took this photograph I was situated between the pitcher and batter. If you find yourself in a position with some danger to yourself (I could have gotten hit by the ball), please stay alert. Better safe than sorry. There's always another opportunity to take photographs.

An unusual viewpoint

A great shot can be conjured up when you get a shot of the subject from a view point that is not easy to reach. Behind this picture was a frantic moment of trying not to slip, fighting the push of the waves, and keeping the camera above the water. But the payoff was worth every anxious moment involved in getting the shot.

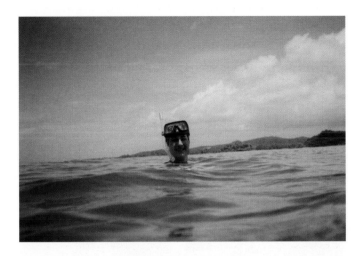

1 With whatever the subject is, consider how to get a shot at an unexpected angle. This could be looking up or down at the subject.

2 If the subject is still life, or a patient person, reposition yourself and the subject in several different ways and decide later which shot came out best.

HOT TIP: If you are willing to forgo quality for some fun, find a shop where disposable cameras are sold. There is a model specifically for underwater photography.

HOT TIP: You can put your camera in a clear plastic bag when near the water. If you shoot away from the sun and avoid any reflective surfaces, the photograph will probably not show any difference from the plastic. Just be careful of your lens moving out when you turn the camera on.

Capture a different view

When taking a shot of people there is no hard and fast rule that says you have to get their faces in the picture. This scene was taken on a jaunt through a woody area. The gentle gait and camaraderie were just as apparent from taking the shot from the rear of the group. After all, lugging around all this camera gear slowed me down.

The effect of framing is evident in the photograph. The path is bordered by rows of dried up plants. Also the two women are framed within the two taller men. What's more interesting is that the women are together and the men are not, but even so the heights of each pair worked in favour of the composition.

? DID YOU KNOW?

The varying height of the children provides a good sense of perspective. The tall boy closest to the camera is actually shorter than the girls. This makes visual sense. Closer subjects should appear larger.

Capturing a group's attention

Taking a shot of a group of people in any situation where they are unaware of your presence and their attention is elsewhere can capture a wide range of expressions and interest, and can bring a picture alive. In this picture, the focus of the shot is the Liberty Bell in the foreground, but the actions and expressions of the people in the background provide interest and curiosity.

The group shot

It's a fact of photography – the more people you try to control, the less success you will have. Taking a shot of a group can be nightmare. There is much to achieve – making sure everyone fits in the view, making sure all can be seen (no one is blocked by anyone else), making sure everyone is staying still, and last but not least, hoping that no one sneezes, blinks, yawns or looks away.

1 Remember patience does not last long when people are standing close to each other.

2 Do your best to get everyone's face unobstructed and to look at the camera.

This group is very cooperative. Everyone is looking in the correct direction and smiling.

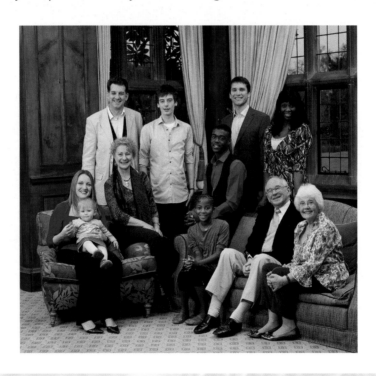

 HOT TIP: 'Say cheese', 'Look at the birdie' and all those overused expressions are just that – overused. A great way to get people's attention is to have something unusual ready to show them. What this is I'll leave up to you. Also, don't tell a joke, it will take too long. If all else fails yell 'Oh no, the camera is broken!' Everyone will instantly look at you, and in that instant take the picture.

People and pets

There's something pleasant in seeing pets and their owners having a good time outdoors. Especially nice is a gathering of numerous pets and people enjoying their time together. In the middle, a couple of dogs are fast asleep. However, the borzoi on the left and the greyhound on the right add a frame of sorts to the scene. Note too that the dogs are along the lines of the rule of thirds.

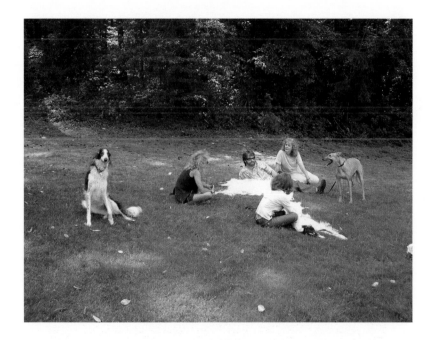

1 Visit a park that is pet friendly at a time when you have no pressing schedule.

2 It might take a while to find a good scene of people and pets, so walk around, enjoy yourself and shoot photographs as the opportunities appear before you.

HOT TIP: It's easier to take pictures of dogs after they have had a good walk or runaround. Once they have slowed down a bit they are easier to capture in good shots.

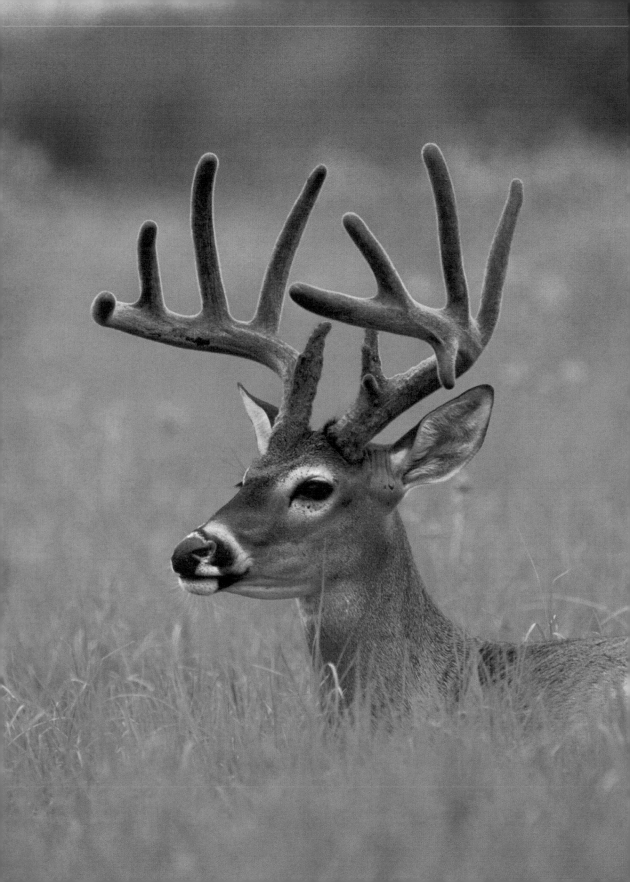

8 Animals

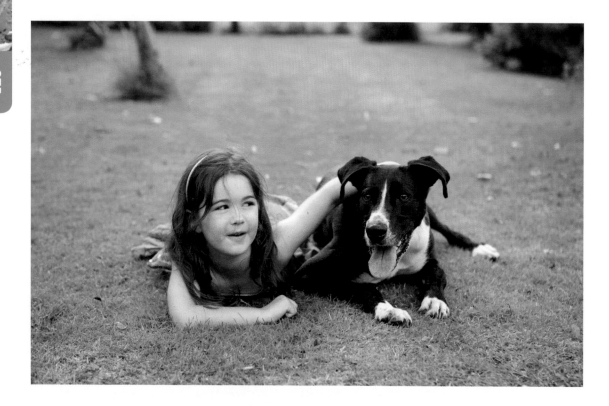

Introduction

With people you can talk, be understood and expect the people you are photographing to react reasonably well to your directions. With pets, the idea is the same but the approach of course is different. Some pets will respond to voice commands – dogs are most agreeable. Other pets can appear to understand, while yet others are just beyond any speech as communication. If you are a pet person you might relate to the thought that your pet understands you regardless of how odd that seems on the surface of it.

Outdoor animals, wild animals and animals at the zoo require another approach altogether for getting good shots. I don't think a lion or a lamb will pay much attention to you, unless they are thinking about food. Yes, food is the great animal motivator. This is true for nearly all animals, including pets.

This chapter presents a hodge-podge of animals and how the shots were taken. Especially with wild animals – these are like taking candid shots – you can't expect any posing. It's up to the fallback method of shoot, shoot, shoot.

Dressing up the dog

There are many types of dog owner. Some lay human attributes on their dogs, and often the dogs go along with it. We can only guess what a dog is thinking: this is fun; I'm getting a lot of attention; or perhaps a special treat is on the way!

No matter what the motivation of the human and the dog, dressing up the dog can create the cutest shots.

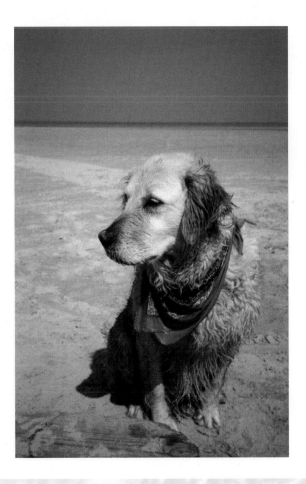

 DID YOU KNOW?
One of the great dog-focused photographers is William Wegman. His photographs of Fay Ray, his pet companion, are legendary in the photo world.

HOT TIP: Dogs are motivated by food, but the amount can be little – which can stretch the food out without piling on the pounds. One little dog treat will keep a dog intent on waiting for the next little taste.

A boy and his dog

A dog is a man's best friend – so the saying goes – and this is even more true of a boy and his dog, who are often inseparable and can provide some truly memorable pictures. If you have time and space on your memory card, you can quickly fill it up with dozens of photos of a child and their dog interacting. In this picture, the bond of love and trust between the boy and his canine companion is captured in the boy's expression and the content look in the dog's eyes.

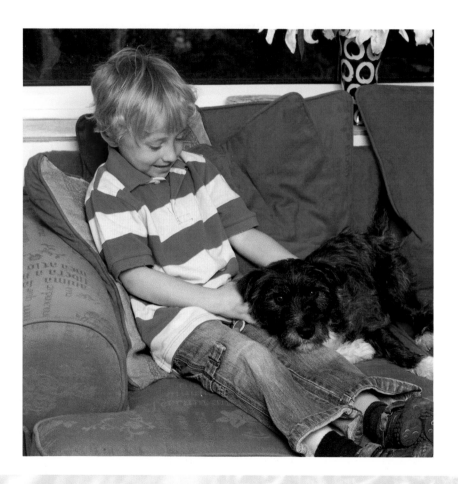

 HOT TIP: Avoiding having the child looking up at the camera makes this photo more spontaneous and natural, and captures the emotion and feeling much better – so avoid saying 'cheese' too often to take shots like these!

Getting a cat's attention

Being the aloof creatures they are, cats are attentive when they feel like it, not when you feel like it. So to get a cat's attention something special is needed. Not all cats are motivated by food, but there is something you can find at your local pet shop that no cat in the world can resist – a laser beam. These little gadgets that cost a few pounds and run on a battery can give you all the action shots you need of a cat.

The beam's spot will draw the cat into a full hunt mood. As you move the beam the cat will follow, chasing the beam even up a wall as far as it can jump (well at least my cats will). The point is that with a laser you can quickly get your cat into action.

1 Purchase an attention-getting toy for your pet.

2 Have someone play with the pet while you take photographs.

HOT TIP: Cats involuntarily blink when a flash is used. Try to get cat photos without using the flash.

DID YOU KNOW?
Cats are attentive to sound. To take a picture of a cat looking at you, blow a whistle while pressing the shutter button.

Butterflies, take 1

Butterflies are one of nature's beautiful creatures but it's difficult to get good pictures of them. When they land on a flower and you get close enough to take a picture, off they go into the air. Lucky for me I found a place that raises butterflies and allows people in to walk around this huge completely closed environment. No flash was allowed here but the enclosure had a glass roof and enough sunlight was present to get some good shots. These butterflies are perched on a butterfly feeder.

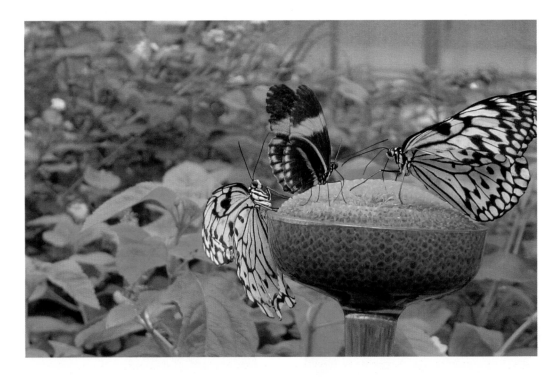

The picture was taken with a shutter speed of 1/200 of a second. The aperture setting is f/5.6, which produced a somewhat blurred background that helps accentuate the clearness of the butterflies.

 HOT TIP: This is what a photographer is sometimes faced with: a place where no flash and no tripods are allowed. In this particular environment, once a butterfly landed on a leaf or a feeder, it tended not to move for several seconds. The pictures came out well by putting the camera on shutter priority with a setting in which hand shaking would not have enough chance to ruin the picture

Butterflies, take 2

These butterflies were hanging upside down. The light worked in my favour here as well. The shutter speed was 1/500 of a second and still there was enough light to get good detail for what is a rarely-used shutter speed for indoor, non-flash photography.

1. The best way to capture a shot of a subject that is almost always in motion is to track the subject through the eyepiece while they move/fly around. Keep your finger on the shutter button.

2. As soon as they land (or stop moving), press the shutter to get a shot. Burst mode is helpful in this situation. You often need to get many shots from which to select the best.

 HOT TIP: A good shot can be anywhere, literally! This shot was considerably higher than where I could reach. A bit of zoom did the trick.

Capturing a bird in flight

Taking pictures of a flying bird requires fast reflexes, and using burst mode is helpful. The technique is simple in concept – track the bird with the camera while taking shots. With burst (continuous) mode on, just leave your finger on the shutter button while following the bird.

1 To 'get close' to a flying bird, zoom is necessary.

2 This type of shot is best taken against a cloudy sky; the contrast is better and a bright sun will not wash out the scene.

The cloudy background was a help in this photograph. Besides providing a background to gauge the bird against, the exposure did not become washed out since it was a cloudy day. Bear in mind that I took a series of shots in burst mode using auto exposure. The camera did a good job. The focus on the bird and the contrast are both good. If the photograph seems a bit dark, this can always be corrected with photo editing software. The exposure settings for this photograph are 1/320 of a second at f/6.3.

 HOT TIP: Depending on how bright the sky is, it is probably easier to see the bird using the view finder and not the LCD.

Duck friends

Some birds spend their time high up; others spend their time on the ground. Ducks, geese and other similar birds are easy to photograph and are often stationary enough to get good detail. In this picture I was able to get a number of keen visuals. The bright orange legs and the dark green head came through well. The reflection in the ice is nice as even the ice itself is clear enough to show any imperfections.

The shutter speed here is 1/30 of a second. This attests to the stillness of the ducks. Had they been in motion they would be blurry at this shutter speed. This somewhat slow shutter speed allowed more detail in the picture.

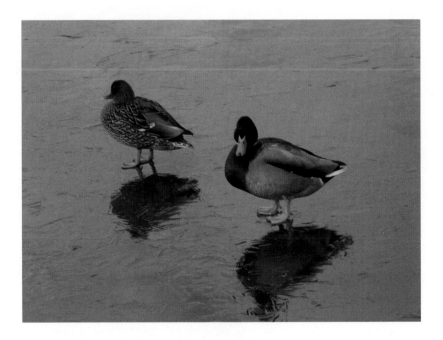

 HOT TIP: Shoot to include shadows. The shadows of the ducks are near perfect in shape and provide great contrast in the shot.

Farm animals

A variety of animals can be found on a farm and there are many great personalities. Some are friendly, some are not, and some are oblivious to you. This goat was a friendly creature that gladly came to the fence to meet me, so what else could I do but immortalise her in a photograph?

The problem here was that, as friendly as the goat was, she did not know how to stay still! This became one of those times where you just have to shoot and hope for the best. At least the wood around the periphery of the scene gives a sense of framing.

 DID YOU KNOW?
This picture is good because the camera and the goat are on the same level. Shooting down at the goat would not have produced as nice a picture.

Taking shots at the zoo

A decent-sized zoo provides a marvel of photographic opportunities: many animals, many behaviours and much variety. Perhaps the most important considerations are capturing animals in a way that shows perspective (to gauge their size), that shows the texture and/or colour of the hides or skins, and if possible to leave the other spectators out of the picture.

1 Find an interesting scene with animals – preferably with more than one – for scale.

2 Zoom in and then zoom back out enough until the animals are present but no other distractions, such as a fence or other people, are in the shot.

In this photograph the bison is framed by the two pieces of wood in the foreground and the tree leaves above. The wood also provides the sense of scale. Another good aspect is that the animals are grazing – in other words, just being themselves, oblivious to their zoo surroundings.

 HOT TIP: It's real easy to bang your camera walking around a zoo. Be careful. And did you take those extra batteries?

9 Nature

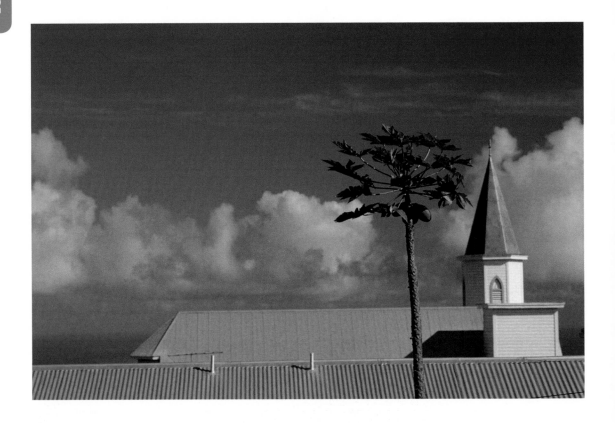

Introduction

The natural world shows beauty in all shapes and sizes; from a snowflake to a mountain, from a flower to a vista. This chapter shows how to capture the large and small – and the colourful. Sun, rain, clouds, clear skies, water, ice and dirt are all here. Sometimes the obvious is the focus of a scene, such as a flower among many. Sometimes the image grabs your attention for other reasons – a shape or a line of implied motion.

Clouds

They come in all shapes and sizes. They can be light and airy, or they can be heavy and dark. No matter how they appear, clouds are a wonder. At the early part of the day or the end they are photogenic. Also when heavier rain clouds are moving in, photo opportunities are there for the shooting.

The first shot shows how contrast is a key factor in good cloud compositions. The clouds in the foreground of the image appear prominent against the clouds in the background. Also the foreground clouds have contrast within themselves as they have their own light and dark areas.

The streaks of cloud in the second photograph carry implied lines of perspective down to the tree in the distance. With this place where the eye has been led to, the image has a sense of resolution or completeness. When waves of clouds roll across the sky they can appear to have no discernable beginning. This shot captured the essence of a focal point.

 HOT TIP: Clouds may have unusual shapes but can still appear plain without some contrast of colour, scale or perspective.

On the beach

Many beach scenes show the sand and surf. A useful twist on the beach scene is to focus on a beach-related artefact, such as this driftwood, and show enough beach in the background so the viewer still knows where the picture was taken. The angles of the driftwood in the second shot especially provide an intriguing look.

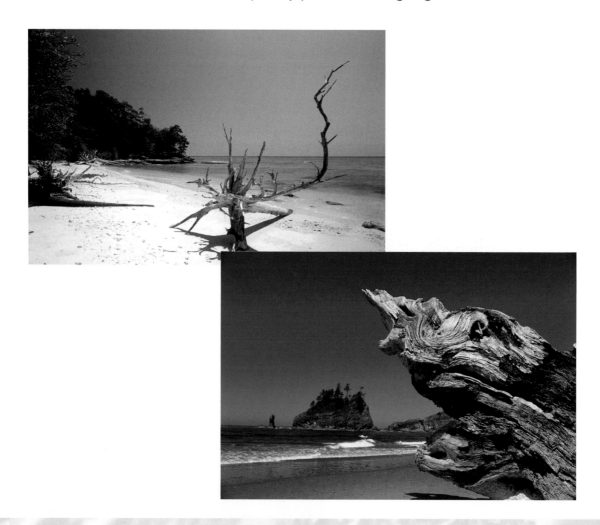

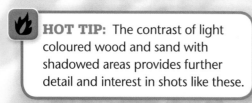

HOT TIP: The contrast of light coloured wood and sand with shadowed areas provides further detail and interest in shots like these.

On a windy beach

This picture implies a windy day as it captures the motion of the grass being blown in various directions. A bit of drama is added with the almost black and white treatment of the subject. The reduction in colour increases the contrast and makes the wind's influence and action that much more apparent. The blurring of the tops of the grass shows the movement of the grass and the action of the windblown sand to capture the moment.

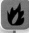 **HOT TIP:** Black and white and greyscale photography open up avenues of new expression. When taking colour literally out of the picture, the contrast of light and shade becomes the creative focus.

Fog

Fog rolls in and out but not on any schedule you can set your clock to. This is a reason to always have your camera charged and ready to go. This scene was shot in the early morning just after sunrise, although the sunlight was not going to get through the thick air. The result – a scene of beauty delivered by Mother Nature.

1 The first step is simply to have your camera ready.

2 When shooting fog scenes, the best are where there are items that are close and far, as the close ones will be more apparent, and the farther ones will be fainter. This in its own way is a type of contrast.

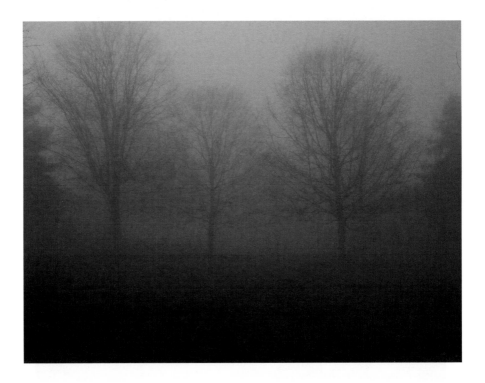

HOT TIP: Fog and the light within it will change fast. Don't fret with looking for a good scene to shoot. Just shoot and keep shooting. Shoot in different directions and different angles.

A lone flower

This image of a single flower fits the bill for composition technique. The flower is clear against a blurred background, and the contrast of colour between the flower and the background is significant.

1 Set the camera to take a macro shot.

2 Include the flower and a bit of its surrounding for sense of scale.

? DID YOU KNOW?

This photograph was taken using the macro setting. The macro setting is so often used with flowers that on most cameras the symbol for putting the camera in macro mode is a flower.

Flowers in a group

This photograph of two flowers was captured very close using the macro setting. At this intimate proximity the flowers' perfections and imperfections are equally clear.

1 Set the camera to take a macro shot.

2 Take several shots of the flowers at different zoom levels and at different angles. Select the best photograph when reviewing them.

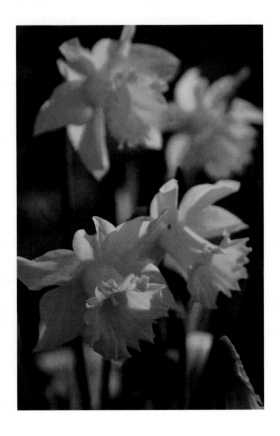

HOT TIP: At this very close positioning (just a few centimetres), even the flower stems are blurred, just as if they might be another couple of centimetres away. Macro photography can produce exquisite effects such as this.

Flowers with a variety of colour

Whether it was planned and planted, or occurred naturally, this beautifully planted display of flowers provides the opportunity to show how a small deviation from perfect planting and planning can add an element of real interest and focus in a chance picture. The single white tulip in the background draws your eye and heightens the perception of the perfection of the ordered rows around it.

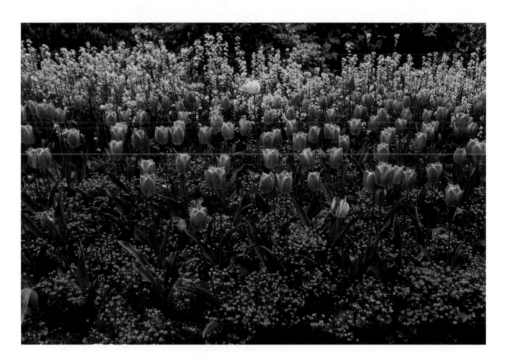

1 Find a field with a variety of flowers.

2 Position yourself and the camera in the best way to get a scene that accentuates one or more flowers because they are somehow different from the rest – by colour or size for example.

 HOT TIP: This is a perfect example of always having a camera handy. You never know what photographic opportunity will unexpectedly come your way.

Near and far

One of the best things about the outdoors is the vast distances you can find. This photograph captures sense of scale quite well. The leaves in front are obviously much closer to the camera than the scenery below. But just how close? One leaf very close to the camera is out of focus; therefore the aperture was not as small as expected. The majority of leaves were actually a good distance from the camera, but nowhere as far as the trees at the bottom.

1 To capture far subjects with some that are near, the best settings are ones with a small aperture (a high f number). Use shutter priority to achieve this.

2 In addition you might also change the auto focus, ISO or other settings to get the best blend of what the camera can provide.

HOT TIP: A scene like this can confuse your camera with regard to what to focus on. Leaving the camera at the default multi-spot auto focus is reliable for the most part – the camera will do the best by sampling various parts of the scene. To be sure of a crisp shot of both the near and far elements, put the camera in aperture mode and dial it to a small shutter opening (a high f number), such as f/16 or f/22.

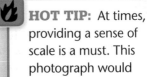

HOT TIP: At times, providing a sense of scale is a must. This photograph would be dull were it not for the leaves.

A lake deep in the land

While on a hike my friends and I peered over the edge of a ravine and discovered a lake that seemed to have never met up with mankind. There was absolutely no telltale sign that anyone had ever been near this lake. Of course it was some 500 feet below us with no easy way to get down.

This photograph is pleasant for a number of reasons. There is contrast of light and shadow. On the near side of the lake the ground is bathed in sunshine. The far side of the lake is in shadow. The water reflects the sunlight perfectly – not too little, and not washed out. The trees next to the lake provide the scale with which to gauge the lake's size.

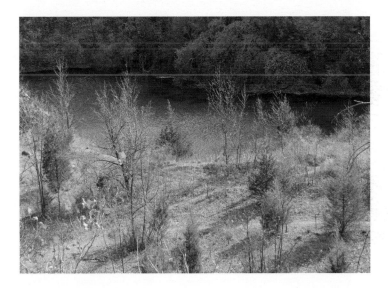

1 When composing a scene of a far away subject, look for some shadowed areas or a way for the scene to include something that is not quite as far. This provides sense of scale.

2 Use the zoom feature to have the far subject appear large enough to show significant detail.

> **? DID YOU KNOW?**
>
> It's interesting that the ground is more barren on just one side of the lake. I suspect the far side of the lake does not get as much sunlight, thereby producing a more tropical type of growth.

Hazy mountains

This picture demonstrates how the feeling of scale, distance and grandeur in a landscape can be captured even when light and atmospheric conditions make details and focus difficult to capture. The evening haze and mist held in the valleys, and the low light of an autumn sunset combine to create soft colours and outlines which heighten the feeling of peace, beauty and scale of this mountain range, and create a perfect, atmospheric shot to treasure.

A clear landscape

In contrast to the previous photograph, this shot shows how focusing on a feature in the foreground can also produce a similar feeling of scale and distance. The rocks in the foreground leads your eye through to the lake and valley, and then on to the distant mountains, creating a feeling of depth and distance that is framed and heightened by the clouds rolling above the scene. This technique captures the scale and feeling of space in a breathtaking landscape magnificently. Compositionally, this shot also works well as the rocks are positioned along a 'third' – so uses the rule of thirds technique.

1 Try capturing a scene without a great amount of zoom. Zoom in to start, and then zoom back out until there is an acceptable balance of the far away with a wider amount of overall view.

2 This type of composition may benefit from use of the bracketing feature. This will provide a selection of shots of the same scene with varying light and dark accents. Check your user manual for how to set the bracketing feature.

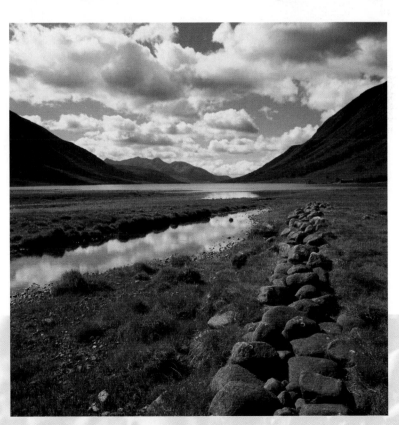

Rain

A rainstorm can be captured in a photograph in many ways but capturing individual raindrops requires a certain approach. Raindrops are typically captured as they bead on a surface. In this shot, drops are found on a leaf, just after a storm has passed.

1 Set the camera to the macro setting.

2 Get close in to the subject so the rain beads are prominent. If you can position yourself in a way that the natural light is striking the beads, they will stand out better.

 HOT TIP: Capturing rain as it beads on a window pane is another method to use. Using a macro setting, take the shot of the raindrops through the glass.

Ice

The qualities of ice are fascinating for photography. After an ice storm the opportunities abound as ice can be beautiful and yet also dangerous and destructive. Ice can cover a tree and break it from the weight. Here though is a view of ice made beautiful by the shape of the evergreen it is held to.

1 Take your time – the ice is not going anywhere. Find an interesting arrangement of ice and circle around it until you see the best way to capture the beauty.

1 Try both a close up with the macro setting on, and a shot from a distance with no macro but with zoom. Compare the photographs and keep the best.

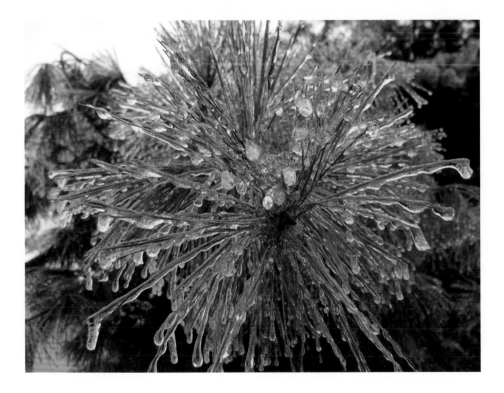

 HOT TIP: Some ice shots are best made using a macro setting but be careful not to scratch the lens on a sharp ice edge.

An unexpected rainbow

If you are even half-serious about your photographic pursuits, then you need to be prepared for anything and everything that you might want to capture. You might be travelling on a day when suddenly the weather conditions become perfect for a display of rainbows, which can appear in an instant, and keep changing, appearing, disappearing and reappearing, sometimes even as perfect double rainbows, as in this shot. There will be no time to change or charge your batteries when opportunities like this present themselves to capture natural phenomena that can't be predicted.

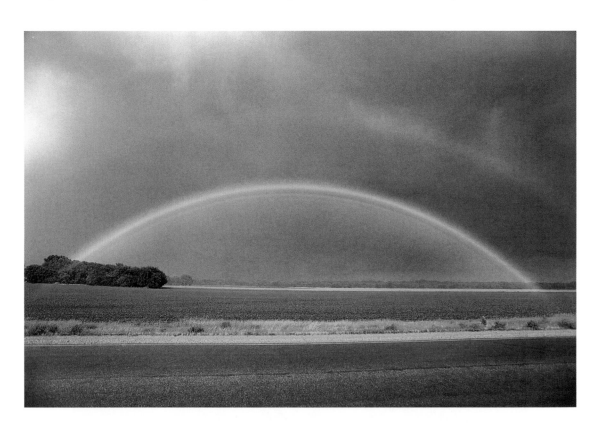

HOT TIP: Nature changes fast and is unmerciful in waiting for slow humans fumbling around with camera settings. Put the camera on auto and shoot, shoot, shoot!

Reflections

Autumn is a time when a lot of colour is available outdoors. Often the leaves in autumn are shot with the focus on the trees. Here is another viewpoint and just as gorgeous. The water here moves at a slow pace and therefore getting clarity in the reflection was possible. Using shutter priority at 1/250 of a second was fast enough to capture the scene without the reflected image looking broken up as the water flowed.

 HOT TIP: Using shutter priority to force a fast shutter can provide reflections in fast-moving water as well. It is possible in some situations, if the light is good, to get reflections that you would never see in the water because of the speed of water flow.

Running water

A common technique for capturing moving water is to use a slow shutter and let the water blur. The longer the shutter is open, the smoother the water will be, but much more light will come into the camera. This photograph was shot with a shutter speed of 1/8 of a second. That was enough for the water to move a bit and take on a smooth appearance. The pace of the water makes a difference too. Fast-moving water, especially a waterfall, requires less time since the water is moving faster.

 HOT TIP: To get good results with this technique, take the shot early or late in the day when the light is low. Then not as much light will enter while the shutter is open for the noticeable time. A tripod must be used for this type of photo. You cannot hold the camera still in your hands for the time required for moving water photography.

10 Structures and patterns

Introduction

Throughout our travels, whether it is a walk down the road, or a visit to the city or the countryside, interesting images regularly pass our way. A sense of conformity and organisation is comforting to our view of our surroundings. Scenes with patterns, textures or symmetry are appealing. A view of the unusual or the usual seen in an unusual way plays to our emotions. Some scenes are comforting, such as the pumpkins shown in this chapter, while other images stir unsettling emotions.

A temple's beauty

Places of worship are some of the most interesting architectural achievements. This Buddhist temple was one of the most beautiful and serene buildings I have been in. The symmetry and styling of the building are perfect. The interior was just as fascinating but it was difficult to take pictures inside.

1 Architecture provides many photographic possibilities. Look for a building or other large structure that has an inherent symmetry.

2 Frame the scene so the lines of the building follow as best as possible the rule of thirds perspective, or some similar visual aid.

? DID YOU KNOW?

This type of tiered architecture alleviates any concern about cutting the horizon in the middle of the picture. Each level of the building provides its own horizon.

Peering up at history

The Brooklyn Bridge is one of the oldest suspension bridges in the world. As far as bridges go, suspension bridges offer many interesting shots. The angles of the cables and the height of the towers provide a composite of patterns, angles and lines of perspective. This photograph has been set in greyscale to accentuate the patterns by diminishing the pleasant but distractive colour.

1 When shooting skyward, avoid the sun. Position yourself so the sun is not in the scene.

2 Try to get portions of the subject that are close and far.

 HOT TIP: Getting a shot like this may require you being in a vehicle with a sunroof or in a convertible. If you wish to chance it you can hang your camera out the car window and point up. Make sure the camera is dialled into a fast shutter speed.

An arrangement of leaves

As leaves mature and change into autumn colours, the veins running through them become prominent. A close shot of a leaf or a small group presents interesting angles and contrast. The veins run darker and in some way mimic the tree from which they fell.

1. Find a subject or scene that has a good amount of contrast.

2. Set the camera to the black and white setting to take the shot. Check your user manual for how to set the camera to black and white.

HOT TIP: An assembly of leaves can be visually rewarding even when in greyscale. With an increase of contrast to accentuate the colour differences, the variation and appearance of the veins retain the patterns within the image.

Capturing the granularity of the grain

This beautiful shot of wood was taken very close up with a macro setting. The line of division is purposely off-centre. The effect of this image is almost a trick of the eye. Although the wood is flat, it can be perceived as folded, the way a book is held.

1 Find a subject or scene that has interesting detail.

2 Set the camera to the macro setting.

3 Get in close to the subject and shoot the photograph.

 DID YOU KNOW?
A sense of scale is missing here. We know it's wood, but what size?

HOT TIP: The angle in the wood is similar to that seen in the leaf. A leaf placed over the wood would have provided a perfect sense of scale.

The happy old carriage

This dilapidated old train carriage sits in a field of grass. It is quite old but oddly retains its bright red shine.

The carriage had so many angles, bright and rusty spots and detailed machine parts I just couldn't get enough of taking pictures of it. Here are a few other views.

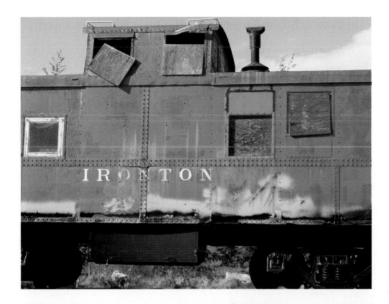

 HOT TIP: Here is another example of the shoot, shoot, shoot approach. When I saw this dilapidated train car I didn't spend much time thinking of what would make a good shot. I just kept walking around it and shooting, getting on the ground and shooting, I even climbed a tree and took more shots. All in all I took over 200 shots.

A tower, real and reflected

With regard to the previous photograph, this is the Washington Monument the way most people expect to see it. The monument does tower over the other nearby attractions, and the reflecting pool does just what it is meant to do. There is symmetry in both the horizontal and vertical planes. The monument and its reflection are symmetrical, as are the trees on both sides of the reflecting pool.

1 Look for a scene in which there is symmetry – typically similar items on the sides.

2 When searching for the best way to capture a symmetrical scene, it often has to do with your distance to the scene. See how the view changes if you step back a few meters or come forward.

HOT TIP: Looks can be deceiving. It appears as if the Washington Monument is taller than the reflecting pool's length. Not even close. The Washington Monument is 169 meters tall. The reflecting pool length is 618 meters.

Getting in the mesh

A picture of mesh fencing would be dull on its own. This scene works though because the boys provide the needed scale, and the positioning up to capture the scene is intriguing. You can just about tell from these elements that the boys are walking through some type of obstacle course.

1 When taking a photograph through a fence or other type of gating, attempt to compose the scene at an upward or downward angle. The distraction of the fence or meshing will have some perspective and accentuate the angle you are shooting at.

2 Be sure that there is something recognisable in the scene, otherwise it will be difficult to gauge the size of the mesh pattern.

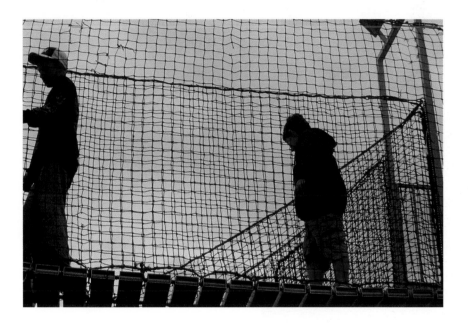

 HOT TIP: Mesh patterns come in many varieties and some creativity can put them to good use. A fine mesh is what a screen or a kitchen colander is made of. Taking pictures through fine mesh will alter the properties of the light. Experiment!

Repetitive patterns

The design of this wall was too good to pass up. As suggested throughout the book, I took many shots of this wall, from different positions and distances. This photograph is the 'keeper'.

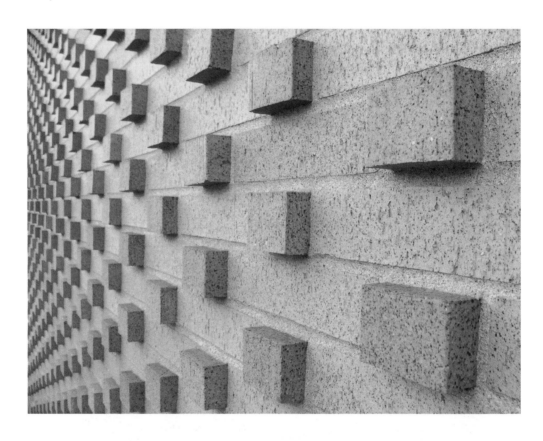

 HOT TIP: Think depth, think scale. Getting close to the bricks and capturing how they fan out created the great effect in this scene.

Looking up through a slatted roof

This shot was hard to get balanced with respect to the sunlight. It was a very sunny day. Lowering the exposure helped but took away from the detail in the wood. So it was one of those 'take what you get' shots. Yet not bad all in all – patterns, shadows, and you can even think the overexposed area falls within the rules of thirds. OK, I'm really stretching it there.

1 When aiming up through a slatted or other non-continuous roof, be sure the sun is blocked by a part of the roof.

2 Experiment with shutter speeds and aperture openings to lighten or darken the scene. Interesting shots can be made this way.

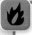 **HOT TIP:** The least desirable time of day for photography is the range of hours when the sun is overhead. Shots get overexposed. But if you find yourself somewhere at that time either take some shots (and hope) or come back later.

Church windows

Photographing a church up close and hoping to get the steeple is no easy task. Here instead is a way I captured a church scene with the suggestion of the window type one would expect to see.

The roof angle conflicts with the natural level of the church, but this was one of those shots where my choices were limited. To get a full set of repeating windows I had to include part of the roof.

1 Zoom in on a set of repetitive windows.

2 Include some extraneous section of the building around the periphery. This helps keep a sense of scale.

? DID YOU KNOW?

Would you know this was a church if I had not mentioned it? Sitting on the laurels of photography being an art form, it is valid to let the imagination fill in the blanks. These windows are also similar to those in universities and other old-fashioned buildings.

11 Special techniques

Introduction

The basic concept of photography is to point, focus and shoot. Past that, the rest is up to the photographer and the creativity one can muster. Your camera provides many options to get beyond the basic photograph. This chapter showcases some ways to be creative and to try some new ideas, all in the interest of making interesting images.

Black and white photography

The term black and white photography is misleading. When a camera is set on a black and white photography setting, it is reducing colour and producing a greyscale image. There are 256 shades of grey for the camera to use. This greatly reduces the ability to show subtle differences in hue, but this is the wonder of this art form. There is less reliance on colour to create beauty and instead the focus is more on contrast. You work with less and create more with less.

1 Place the camera on the black and white setting.

2 Experiment with various scenes and subjects. Look for contrast – light and dark areas, shadows, and so forth.

3 If you wish, shoot the scene in both colour and black and white. This helps to see how contrast plays a major role in good composition.

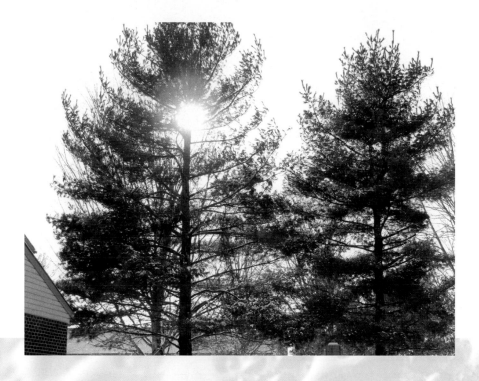

 HOT TIP: Look for scenes where there is a variety of light and dark. Capturing contrast brings the shades of grey to life. The variation may be small but the images in their starkness can be stunning.

Sepia photography

Sepia is a shade of brown that is found in old photographs. Including this is an option in a modern camera to simulate the old-fashioned look. Sepia photographs are comprised of 256 colour variations, similar to greyscale.

1 Place the camera in the sepia setting.

2 Experiment with various scenes and subjects. Look for contrast – light and dark areas, shadows, and so forth.

3 If you wish, shoot the scene in both colour and in sepia. Comparing the photographs is educational to see how sepia might be useful in future photographs.

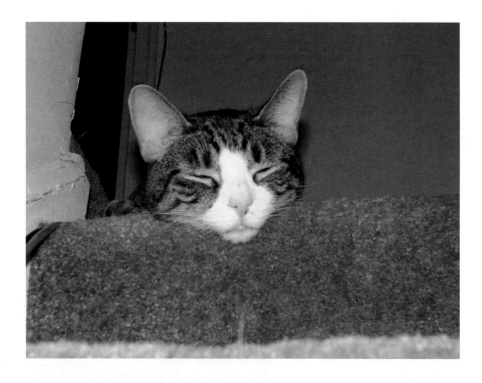

 HOT TIP: Like greyscale photography, sepia photography is best when contrast is accentuated. Here, the cat's white face against the dark brown carpet makes the scene work well.

Macro photography

Macro photography is the art of shooting up close. The camera has a setting for macro mode, usually symbolised by a flower. Flowers are popular subjects to shoot close up.

Macro photography can make everyday objects look extraordinary. Detail can be seen that normally would be ignored, such as the imperfections in the wood and graphite point of a pencil.

? DID YOU KNOW?

Positioning the camera and the subject when this close up can create a problem. The camera body or lens itself may be in the way of the flash. This problem is demonstrated in this macro shot of a shell.

The zoom trick

The technique here is to change the zoom while the shutter is open. The result is a shot that appears to move out from (or towards) the centre.

To do this the shutter needs to stay open long enough for you to change the zoom. The camera must be on shutter priority or manual mode. A tripod is helpful to keep the camera steady, but since the image will look like an odd mix of clarity and blur, some camera shake could add to the artistic effect.

As with any slow shutter speed, more light enters the camera so the aperture needs to be small.

1 Place the camera in the shutter priority setting.

2 Set the shutter speed for one quarter of a second.

3 Start zooming (in or out) and then press the shutter button.

4 Try step 3 with a variety of shutter speeds, from one second to an eighth of a second. This is subjective as the amount of light will make a difference as well. A tripod is likely to be necessary for longer shutter speeds to avoid shaky photographs.

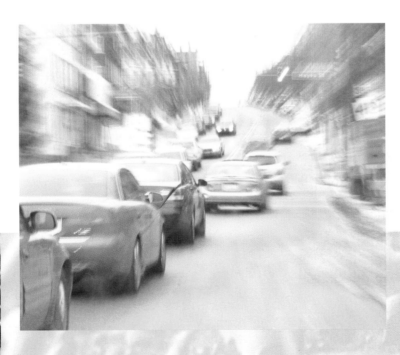

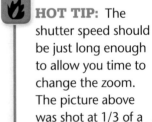 **HOT TIP:** The shutter speed should be just long enough to allow you time to change the zoom. The picture above was shot at 1/3 of a second.

Night photography

With a tripod and a shutter that will stay open, creative opportunities abound when the sun goes down.

One common night shot is the congregation of light from cars. Leaving the camera on a tripod with the camera aimed at a stretch of road, you can capture the streams of light from car head- and brake-lights.

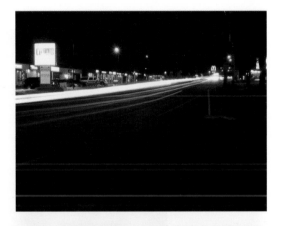

Looking in a brightly lit store from the outside can also produce an interesting shot.

Brightly lit exteriors, especially with vivid neon colours, provide a wealth of creative imagery.

1 Place the camera on a tripod.

2 Put the camera in shutter priority mode.

3 Experiment with different shutter speed settings, even up to several seconds.

HOT TIP: The second and third photographs are blurry from hand shaking. The exposure times were longer than can be kept steady by hand. Creative licence is allowed in night photography!

Shooting through a cutout

This technique is to put an object in front of the lens that has an opening that is smaller than the full image area. This photograph was taken by holding a music CD in front of the lens. The image is seen through the small circular opening in the centre of the CD.

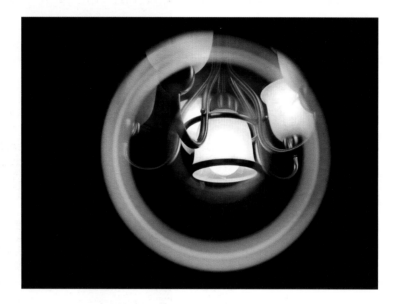

1 Find an item with a circular opening in the middle that is about the size of the housing around the camera lens. Some useful items are CDs or DVDs, cardboard tubes, or even the lens hood for your camera.

2 Put the camera on a tripod.

3 Hold the item slightly away from the lens, with the opening where the lens is, and shoot a photograph.

4 Experiment with how close to hold the item.

 HOT TIP: Look around your home. There are many items that can be used to shoot through. The shape can be anything. You can even 'theme' the picture. For example, find a heart-shaped cutout and you have the making of a Valentine's Day or anniversary gift.

Intentional colour imbalance

Your camera may have a selection of white balance presets. The purpose is to set the colour balance for the type of lighting you are shooting under. For example, you can select a preset for fluorescent lights when shooting under such lights. The camera shoots with an auto white balance setting if you don't select a preset. That works fine for all your photography fun.

1 Set up a scene that will stay fixed and under a constant light (indoors is best).

2 Shoot the scene with different white balance settings. Consult your user manual if necessary.

Here's an idea that may produce an interesting photograph. Shoot the same scene repeatedly, each time with a different white balance preset. The photographs will differ in overall colour, and what might look unnatural can be considered a purposeful effect. Here are two shots made with two different presets.

SEE ALSO: For more information on white balancing see Chapter 6.

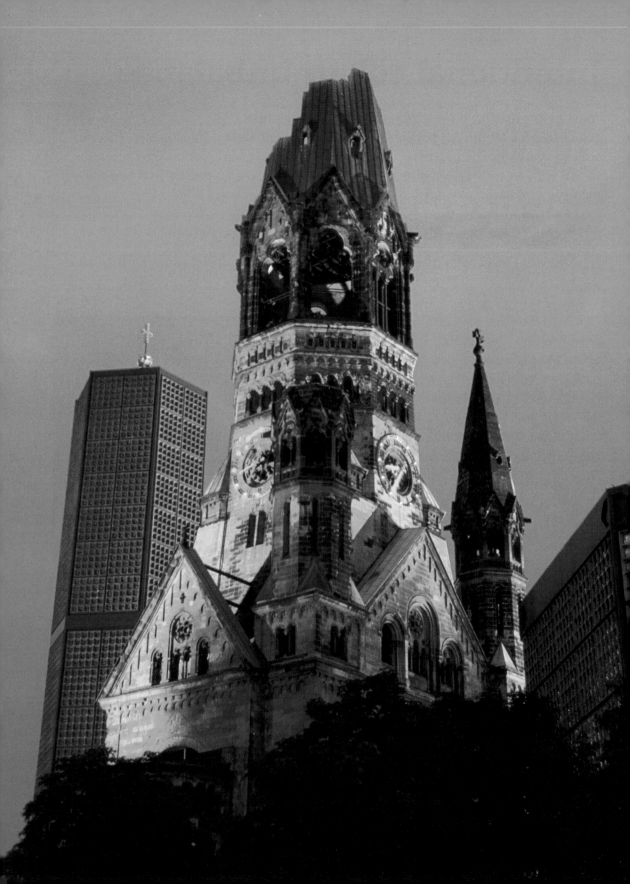

12 Photo editing with Photoshop Elements

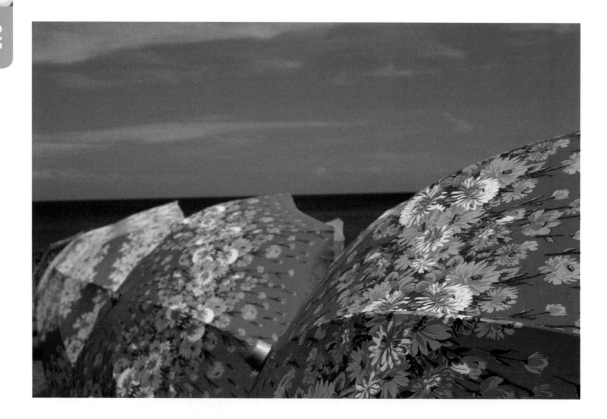

Introduction

All the photographs taken with your camera can be altered using software. The reasons to do this are plentiful. In the days of film, image manipulation could be managed in the darkroom. Today's equivalent is photo editing software. One of the leading programs is Adobe Photoshop® Elements.

Photoshop Elements is a comprehensive package that has the power to alter images in just about every way imaginable. This chapter shows 'before' and 'after' image changes that are on the easy and commonly used end of the software's ability. There is an excellent book from this series that will allow you to delve into the wonders of Photoshop Elements – *Photoshop Elements 8 in Simple Steps*.

The editing area

This chapter references tools and menus in Photoshop Elements. Here is a picture of what the editing area looks like. The toolbar is on the left, and the menus are on top. Manipulations are made to the photograph in the editing pane.

If you are not sure how to get the image files from your camera into your computer, consult your user manual.

 DID YOU KNOW?
This is the Editor. Photoshop Elements also has the Organizer. In the Organizer you can categorise photographs, add keywords and ratings, and much more.

 HOT TIP: All image manipulations can be reversed if you are not satisfied with the result. The software has an undo function.

Auto Color Correction

Just as your camera can operate in automatic mode, Photoshop Elements provides a handful of auto corrections. Auto Color Correction changes the colours found in an image.

1 Click on the Enhance…Auto Color Correction menu.

HOT TIP: There are many manual ways to change the colours in an image. If Auto Color Correction does not provide a pleasing result you can change colours using other methods.

Auto Contrast

Auto Contrast works by accentuating the colour or light differences in the image.

1 Click the Enhance…Auto Contrast menu.

The contrast between the snow and the trees, rocks and the gazebo is increased by the darker items being made darker. Auto Contrast works with what you give it. Other images may very well be handled differently, such as making a bright area brighter. With some images there is no noticeable difference if there are no big variations in the image to begin with.

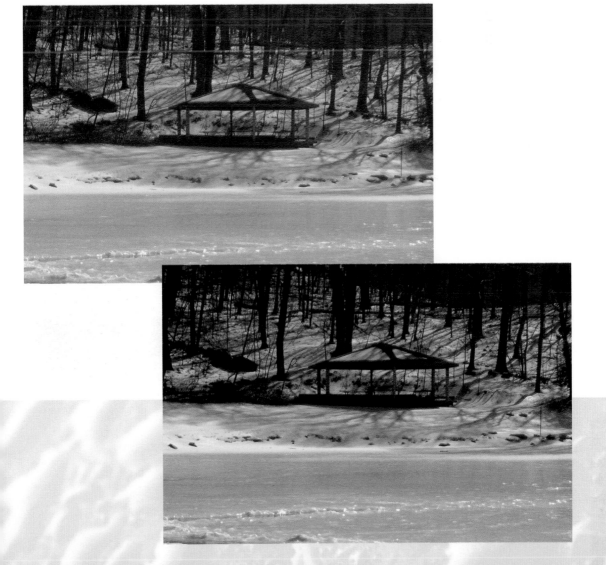

Auto Levels

Auto Levels adjusts the brightness applied to colours. Since an image is a composite of many colours, the effect is unique to each image.

1 Click the Enhance…Auto Levels menu.

? DID YOU KNOW?

In the realm of the digital, all colours are a combination of red, green and blue. Changing levels using the built-in manual method lets you work on all colours together, or one at a time.

Color Curves

The approach of using curves – adjustments visualised as a line on a graph – is applicable to various types of image manipulation. Here, colours, brightness and contrast are altered by changing the shape of a linear line on a plot area.

1 Click the Enhance...Adjust Color...Adjust Color Curves menu to display the Adjust Color Curves dialogue.

2 The dialogue shows the before and after image. Select a style in the list on the left and then use the slider switches to alter the line in the plot area. Click OK when done.

? DID YOU KNOW?

Only one change can be made at a time. To make more than one change, make one, save the file and then open the dialogue box again to make the next change.

Color, Hue and Saturation

For practical purposes, hue is the same as colour. Saturation is the amount of the applied hue. No saturation results in an image with just shades of grey. Full saturation makes colours deep and vivid. In Photoshop Elements, hue, saturation and lightness can be altered all at once.

1 Click the Enhance…Adjust Color…Adjust Hue/Saturation menu to display the Hue/Saturation dialogue.

2 The dialogue previews how the image appears with the applied changes. Click OK when done.

Color Cast

Photographs can appear with an undesirable colouring effect from the lighting under which the photograph was taken. A common example of this is a yellowish tint from an incandescent bulb.

1 Click the Enhance…Adjust Color…Remove Color Cast menu. A small dialogue appears. In the dialogue is the eyedropper tool. Using the eyedropper, click on a place where white, black or grey appear in the image. The image will update with a correction to the colour cast.

 HOT TIP: It may require quite a bit of clicking around with the eyedropper to arrive at a decent colour cast correction. The change is quite sensitive to the 'sample' you provide with the eyedropper.

 HOT TIP: You can also use the colour cast correction method to apply a purposeful colour effect. As you click around with the eyedropper tool, the entire colouring of the image can change. This could provide an effect worth keeping!

Convert to Black and White

An interesting effect is to remove colour. Although an image might be referred to as black and white, often the image is greyscale. True black and white would be just those two colours. A greyscale image can have up 256 shades of grey.

1 Click the Enhance…Convert to Black and White menu to display the Convert to Black and White dialogue.

2 Select a style on the left, and use the Adjustment Intensity sliders on the right. Although they are labelled as Red, Green and Blue (and Contrast), the effect is that, in the greyscale image, the areas that had those colours in the original are altered with varying shades of grey. The before and after images let you see the changes as you make them. Click OK when finished.

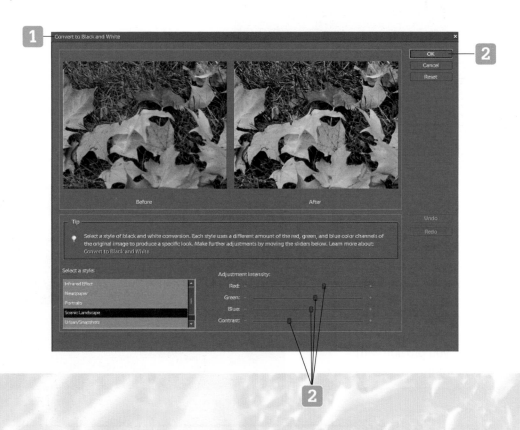

Cropping

Cropping is an easy operation used to remove portions of an image. Typically it is used to keep a well-composed central image area and remove the distracting outer sections.

1 Select the Crop Tool.

2 The Crop Tool draws rectangular shapes. Draw a rectangle over the part of the image you wish to keep. If satisfied, click the accept icon, or click the cancel icon (these icons appear underneath the drawn rectangle). The image changes to its cropped version.

? DID YOU KNOW?

Cropping brings the subject(s) closer as they now fill up more of the image.

Resizing

Resizing an image may be necessary to have it fill a defined area, such as on a webpage, or to make the file size smaller to send in an email. Resizing is best to reduce rather than enlarge an image as definition is lost when an image is enlarged. When images are enlarged they get grainy. The amount of grainy appearance correlates with the amount of enlarging.

1 Click the Image…Resize…Image Size menu.

2 The Image Size dialogue opens. There are a number of ways to resize an image using this dialogue, but the most common are by pixels or by percentage.

The width and height boxes in the upper area are where you should make changes. In the drop-downs next to the width and height are the two measurement types: pixels and per cent. If you want to make an image half of its current size the easiest way is simply to select 50 per cent.

3 Click OK when finished.

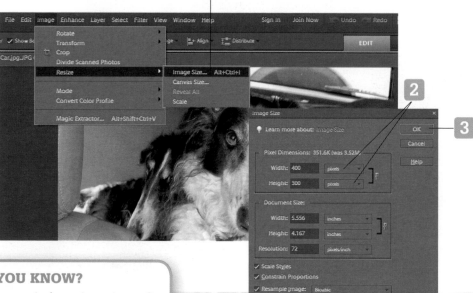

? DID YOU KNOW?

How many pixels are in an image? That depends on what megapixel rating the photograph was shot at. Modern cameras with high megapixel ratings (such as 10 or higher) create an image that is already larger than most computer screens can fully show.

🔥 HOT TIP: Leave the Constrain Proportions box ticked. Then you only need change the width or the height. The other dimension will change accordingly to stay proportional.

Fixing a crooked image

A photograph may end up with an out-of-angle picture. That is, the lines of the subject or other items in the scene are not aligned with the sides of the image, as shown here.

1 Click on the Straighten tool.

2 Holding the mouse button down, draw a line parallel with the crooked angle. Release the mouse button. The image is now straight.

3 There is one problem: the image has been rotated and now the canvas (the part under the image) appears. So, use the Crop tool to cut out the odd looking periphery.

HOT TIP: Use the Image…Rotate…Straighten and Crop Image menu to resize and crop in one step.

Red eye

Red eye can occur when the light from a camera's flash hits the retina of the eye of your subject at a certain angle. If you haven't used the red-eye reduction setting on your camera and capture a great spontaneous shot that can't be recreated, you can still repair the red-eye effect and transform your flawed shot into a 'keeper'.

1 Click on the Red Eye Removal Tool.

2 Draw a box over the red eye and release the mouse button. The red eye appearance will be removed.

? **DID YOU KNOW?**

You can also use the Enhance…Auto Red Eye Fix menu. This method analyses the entire image for where red eyes might occur and then corrects them but is not as exact as using the Red Eye Removal Tool when you tell the program *exactly* where to apply the change.

Apply a filter

Filters apply manipulations to an image. Photoshop Elements has dozens of filters that produce many types of interesting changes. They range from the subtle to some that so affect an image you would not recognise it. Here is an example of applying the Photo Filter.

1 Click the Filter…Adjustments…Photo Filter menu to display the Photo Filter dialogue.

2 Select a filter and a density level. Click OK when done.

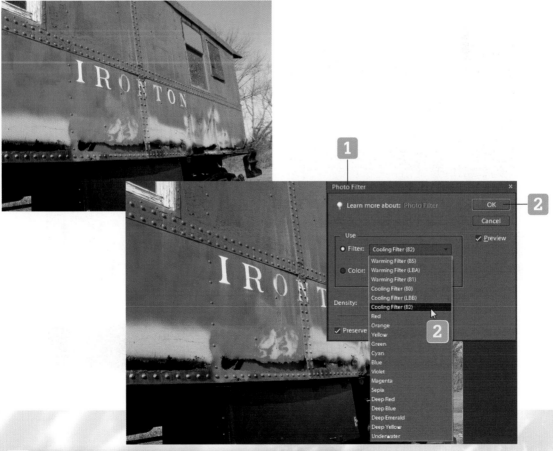

HOT TIP: Use the Filter…Filter Gallery menu to open the Filter Gallery. This is the maximum-size dialogue that has all the filters available in one place to try out. The filters are organised into categories such as Artistic, Distort and Stylize.

Invert

Invert is a simple operation that reverses the colours and appears just like a negative from the days of film.

1 Click the Filter...Adjustments...Invert menu. That's all you do!

 HOT TIP: Inverting is useful for changing a daytime scene to a night scene. The inverted tree appears as if bathed in a spotlight against a dark night.

Rotate

Rotating an image can be done to any degree, literally. There are 360 degrees in a circle and an image can be rotated to any value. Several preset values are available for common needs such as turning an image on its side (a 90-degree rotation).

1 Click the Image...Rotate menu. Then select an item from the submenu.

Flip

Flipping an image reverses its left to right view. This is similar to a mirror effect.

1 Click the Image…Rotate…Flip Horizontal menu.

 HOT TIP: You can flip horizontally or vertically. In fact you can do one and then the other to flip the image in both directions.

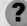 **DID YOU KNOW?**
Horizontal flipping is as if viewing an image in a mirror. Vertical flipping is impossible to make happen with a mirror.

Sharpen

A noticeably blurry picture cannot be made sharp. However, a photograph with a soft look or just minor blur can be enhanced to appear sharper. There is no trick to truly change blur to sharp; instead the effect is created with alterations of contrast and lighting. The details are handled by the software. Here's what you do.

1 Click the Enhance…Auto Sharpen menu.

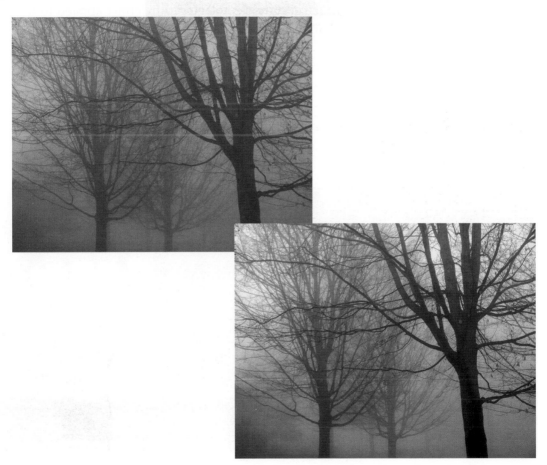

 HOT TIP: For more control click the Enhance… Adjust Sharpness menu. This opens the Adjust Sharpness dialogue. There are several options that can be used in the dialogue, even approaching sharpening in terms of what to 'unblur'.

Selecting

Selecting is the process of highlighting a part of a picture. Selecting itself does not do anything, but selecting an image's area then lets you apply a change to just that area.

There are several section tools and to discuss them all is beyond the scope of this chapter. The hand in this picture was selected using the Magnetic Lasso Tool.

The hand is outlined with a marquee and then is selected. Any effect applied to the image will now be applied just to the hand.

There is also a way to select everything except the hand. Now that the hand is selected, clicking the Select...Inverse menu will toggle the selection.

It appears that the hand is still selected, but notice that the border of the image has a marquee around it. Everything up to but not including the hand is now selected.

HOT TIP: To remove a selection use the Select... Deselect menu.

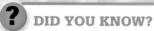

DID YOU KNOW?

Photoshop Elements provides many selection tools, making it possible to create selections of any shape, including freehand shapes. Selections can even be saved for reuse.

Gaussian Blur

Intentional blurring adds to the palette of creative techniques. A popular blur type is the Gaussian Blur, which is based on a statistical function of the same name. Continuing with the previous task, here is a way to put a blur effect to good use.

In the previous task the image was left with a selection that encompassed the entire image except the hand. Now the blur will be applied to the image.

1 Click on the Filter...Blur...Gaussian Blur menu to display the Gaussian Blur dialogue.

2 The dialogue has a setting that alters the level of blur. The result is a clear subject with a blurry background.

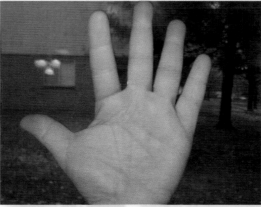

Radial Blur

Radial blur has two variations. One is to blur the image in a spin. The other is to go from a clear centre towards a blurred periphery.

1. Click on the Filter…Blur…Radial Blur menu to display the Radial Blur dialogue.

2. Select the blur method and the amount.

3. The diagram in the lower right corner of the dialogue indicates the type and strength of the blur. Click OK when finished.

File Info

File Info tells you all the facts about your photograph.

1 Click on the File...File Info menu to display the File Info dialogue.

Here is the place to see what the aperture, shutter speed, ISO and size are; how flash was handled; and much more.

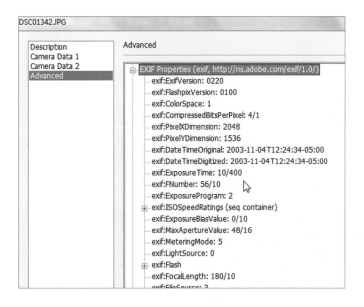

 DID YOU KNOW?

You may need to apply a little mathematics to make sense of the information. For example, the exposure says 10/400 (10 four-hundredths of a second) which is the same as saying 1/40 of a second. The F number is listed as 56/10 which is better known as F5.6.

13 Sharing your photographs electronically and online

Introduction

After the lens cap is back on, the camera is in the case and the photographer's creative juices are spent, comes the sharing of your special work. Printing your photographs – the traditional way of sharing – is covered in the next chapter. Here is the modern approach: put your photos online, email them, create a slideshow, even carry them around in your pocket. And since this is the chapter of many things electronic, also included are backup methods.

Create an album of digital photographs

Photoshop Elements does it all – organise, edit, keyword tag, and more. One of the features is to place photographs into separate albums. These albums are focused on subjects of your choice. That could mean your hobby, your sister's wedding, your camping trip or whatever else strikes your fancy.

Here are the steps to create an album of dogs. First, fire up Photoshop Elements and have the Organizer open on your computer.

1 On the right of the Organizer's working area is the Albums pane. Click the green plus sign button to open a context menu. The first item is New Album. Click on it.

2 You will be prompted for a name to give the new album. Enter a name.

3 Drag images from the Organizer's pane into the album which now has an open area to place the images in. Click the Done button when finished.

4 The album now appears in the Albums collection.

HOT TIP: Instead of clicking the Done button, click the Share button. This leads to options of burning the album to a CD/DVD or to upload the album to a website via FTP (File Transfer Protocol).

DID YOU KNOW?
Additional photographs can be added to an album at any time by dragging them from the main Organizer pane into the album.

Create a slideshow

Slideshows are great! Assemble your favourite shots and then as a slideshow they can be viewed in a timed sequence. Here's how:

1. On the right side of the Organizer click the Create button. In the pane below are choices of what to create. One is to create a Slide Show.

2. Next, a dialog opens in which you make selections about the behaviour of the Slide Show, such as how many seconds each image is displayed.

3. The next dialog is used to select the images for the Slide Show. You can add images from the Organizer and also from within folders on your computer.

4. Add the images you wish. As you do, you can add text to images and further refine the duration of the image before transitioning to the next image.

5. Click the Save Project button to save the slide show.

6. Click the Output button for options where to place the Slide Show – typically to save it as a file or burn it to a CD/DVD.

HOT TIP: If a memory stick or other external storage device is hooked up to the computer, files can be used from the storage device.

Create a CD/DVD jacket

The Create options in Photoshop Elements are numerous, such as creating greeting cards, a CD/DVD label and a CD/DVD jacket. The steps for all of these are similar: here are the steps for creating a CD jacket:

1 In the Photoshop Elements Editor, open the image you wish to use for the cover. Make sure it is visible in the Project Bin. If it is not, select Show Open Files from the Bin Options dropdown.

2 To the right of the Editor pane, click the Create button, then click the More Options button. Then select CD Jacket.

3 You will be prompted to select an optional theme and a layout. Click the Done button when finished.

4 The image will appear in the CD jacket layout, or possibly you will need to drag the image from the Project Bin.

5 Use the File ... Save menu to save the CD jacket. Save as a jpg or other desired file type. The size of the image will match the size of a CD jewel case.

Burn your photos to a CD or DVD

You can use the features in Photoshop Elements to burn images to a disc, but easier still is to just do so with the same feature offered in Windows.

1 Navigate through your computer's folder system to find the folder or image(s) you wish to burn.

2 Right click on the folder, single image, or one of a group of selected images.

3 Select the Send To item from the context menu. Send the image(s) to the writable CD/DVD drive in your computer.

4 Place a blank CD/DVD disc in the writable drive in your computer. Most likely Windows will take over and direct you through the process of burning the images to the disc. If not, consult the help system on your computer, or your user manual.

HOT TIP: If there are multiple images you wish to burn while avoiding others in a folder, hold down the CTRL key while clicking on the desired images. This keeps them selected as a group.

DID YOU KNOW?
The options of where to send the image(s) will differ based on the hardware in your computer. The drive letter may be different.

Share photographs on flickr

Online photograph communities are certainly wonderful to visit. There is so much to see! Better yet is joining an online photograph community and sharing your creative images. One of the leading web destinations is flickr.

Navigate your browser to http://www.flickr.com and join in the fun. Membership is free.

On flickr your photographs become part of your 'photostream'.

You can organise your photos, tag them with keywords, edit your photos and decide how public to make them. This means you can control who can see your photos. For example, just family members, or access can be wide open so the whole world can see your creations. Another feature of flickr is to display your photos in a slideshow.

 HOT TIP: If you have a Yahoo account, you can link your flickr account to your Yahoo account and use the same login for both. Yahoo owns flickr.

 DID YOU KNOW?

There is even more available on flickr. You can receive stats about your photographs – how many times they've been viewed, how the viewers were referred to your images, and so on. You can even find out how many photographs in flickr were taken with the same camera that you have.

Post photographs to your Facebook account

Sharing photographs online is not limited to photographic communities. General social communities love to have your photos too! Facebook is one of the largest social networking sites on the web, so why not post some photos there to share with others?

If you don't have a Facebook account, then navigate over to http://www.facebook.com and sign up. It's free of course.

Once you are logged into Facebook, click on the Photos link on your Home page, then select to upload a photo, take a picture from your webcam, or create an album of photos. When selecting the latter choice, you are able to upload dozens of photos at once.

Photographs can be captioned, sorted, and more.

When an album is viewed, a great feature is that friends can leave comments about your photos. Another nice touch is that Facebook provides a permanent link that leads directly to the album so anyone can see your album – without even having a Facebook account.

 HOT TIP: When you create an album of photos, you can select which photo is the 'cover' photo of the album, and you can change it anytime.

Email your photographs

No doubt the most common way of sharing photographs is to send them on an email message. Depending on your operating system and which email program you use, the screens and steps may be slightly different, but here is the basic method.

1 Start up a new email message.

2 Click the paperclip icon or find an alternative way to add attachments to your email message. A dialog box should appear in which you browse your computer and find the photograph(s) to attach.

3 Select any desired options before sending the email. Shown here, a wise choice is to have the email program reduce the size before sending. Image files can be quite large and some recipients' inboxes will reject an email with attachments that exceed a certain number of bytes.

HOT TIP: If you plan to send a significant number of photographs, send them in a series of emails with a few photos attached to each. Then send a final email with no attachments asking if the recipient received the previous batch of messages.

Display photographs in a digital photo frame

A marvel of modern photography technology is the digital photography frame. These frames come in many shapes and sizes, and for the most part look like traditional photo frames. The key difference is that digital frames display many pictures, not just a single as a traditional frame does.

Digital frames can be costly so do your research before purchasing one. They operate by being loaded with image files, and then the images are cycled through for display in the frame. Some frames have the images downloaded from the computer or possibly direct from the camera. Others have a USB port in which you place a memory stick or other portable storage device on which the files reside. Some even use Bluetooth technology to gather the images through wireless means. One rather interesting variation of a digital frame is one that is portable, typically as a key chain.

This small wonder has a viewing area of about a square inch. Not large, but then again, I can walk around with an entire portfolio in my pocket! And the price can't be beaten. The keychain frame set me back only about as much as a half-decent lunch.

The images are downloaded from the computer via a supplied USB cable and an application loaded on the computer that manages the file transfers.

Backup your photographs to a memory stick

Your camera uses a memory card to store photographs. A memory stick is quite similar. Memory sticks are used as general purpose portable storage devices. They are used to hold all files types, including image files. They are USB devices – that is, they connect to the computer or other equipment through a USB port.

Memory sticks come in varying physical size and capacity. As with any memory centric device, the more memory it contains, the higher the price. However, memory sticks overall are fairly inexpensive and quite easy to use.

Assuming image files are already on your computer:

1 Place a memory stick into a USB port on your computer. Usually a selection of choices appear when the computer recognises a device has been attached to it.

2 You can select an offered option or ignore them all by clicking the Cancel button.

3 The contents of the memory stick are easy to see by accessing My Computer (on Windows computers) and selecting the memory stick. It will appear as one of the computer's drives.

4 Navigate to a folder on your computer where you have your photographs. Right click on the folder and select the Send To option to send the folder to the memory stick.

5 Before pulling the memory stick out of the USB port, look in the Windows system tray (bottom right of the screen) and click the Safely Remove Hardware icon. Follow the instructions in the dialog for turning the memory stick off before removing it.

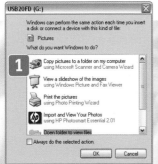

Other backup options

Backing up files is essential and should not be treated as an afterthought. Having duplicate sets of files in different locations gives close to a guarantee that you will not lose precious material. Besides the simplicity of using a memory stick, here are other ways to back up your files.

- **Save files on a portable hard drive.** These are similar in concept to memory sticks but have the capacity to store much more. There is a myriad of types and options. A visit to a local electronics retailer should provide you with some thought on what is suitable.

- **Burn images to CDs or DVDs.** This is explained earlier in the chapter. The only difference here is the purpose. A CD or a DVD is easy to carry around and bring to a friend's house to show off your photos. In the case of backup, you might purchase a package of CDs or DVDs and copy all your work onto them – and then put them somewhere far removed from your computer. Even better still to keep them somewhere outside of your home. A horror of a thought, but if you had a fire in your home, the images are safe elsewhere.

- **Store files online.** Nearly all email accounts and certainly anyone who has a website has plenty of spare storage space on a web server. You can use an FTP program to save your files to an online destination.

 HOT TIP: Your email account or website access involves a login and password. Just as vital as backing up images, is backing up logins and passwords. Don't depend on them to just be 'remembered' by your computer. Keep a written copy somewhere.

14 Printing

Introduction

The antithesis of placing photos online is to have ones you can hold in your hand. After all the technological achievements from which we don't really hold anything tangible, isn't it nice to reach into your wallet, purse, pocket, or bag and pull out an actual photograph you can hold and show off? Ah, the little treasures of life.

Basic computer-to-printer printing

Printer hooked up to the computer? Ink cartridges in place? Then you're ready to go.

1. Navigate through your computer to where photographs are that you wish to print.

2. Select one or more photographs. An icon button will appear to initiate printing.

3. Click the button to open the Print dialog. In the dialog are choices for how to layout the images, how many copies, and so on.

4. Click the Print button. That's it!

🔥 HOT TIP: Simply right click on an image in a folder. In the context menu, select Print. This opens the print dialog. An alternative is to right click on an image in a folder and select Preview. This opens the image in the Windows Photo Gallery. From within this viewer is the option to print.

❓ DID YOU KNOW?

These steps are for Windows Vista. Windows XP and other operating systems will have similar features but may work somewhat differently.

Printing direct from your camera

If your printer supports direct access through a USB port, then it may be possible to print directly from your camera. This also depends on the camera. With so many printers and cameras available it is near impossible to suggest steps that will work universally. This example shows a printer that accepts a USB connection from the camera, and the options to print are made within the camera's menu system.

1 This printer has a USB port in the front. The camera is to be connected to the printer via a USB cable.

2 In the camera's menu system are printing options.

3 A further option is to print a single photograph or all the photographs on the camera's memory card.

ALERT: Don't select to print all the photographs unless you are sure how many there are and that you really want all of them to print. Since hundreds of photographs might be on the memory card, proceed with caution.

HOT TIP: Your printer may support having the memory card inserted directly into the printer. In this scenario, either a menu panel on the printer, or on the computer to which the printer is hooked up, will allow you to select which images to print.

Using an online service to create prints

Imagine you need or desire to have real prints made of your photographs, but want them delivered to you. Why not? The web abounds with services that cater to this very whim.

One of the largest online print services is PhotoBox. Visit http://www.photobox.co.uk and register to open an account – free of course. PhotoBox stores images, creates online albums and more. As for printing, there are many options and usually specials are available.

There is even a way of printing an image onto a canvas, just like a painting. These are bit more costly but rather impressive. And they make great gifts! Whatever your needs, you're sure to find a way to fulfill them at PhotoBox.

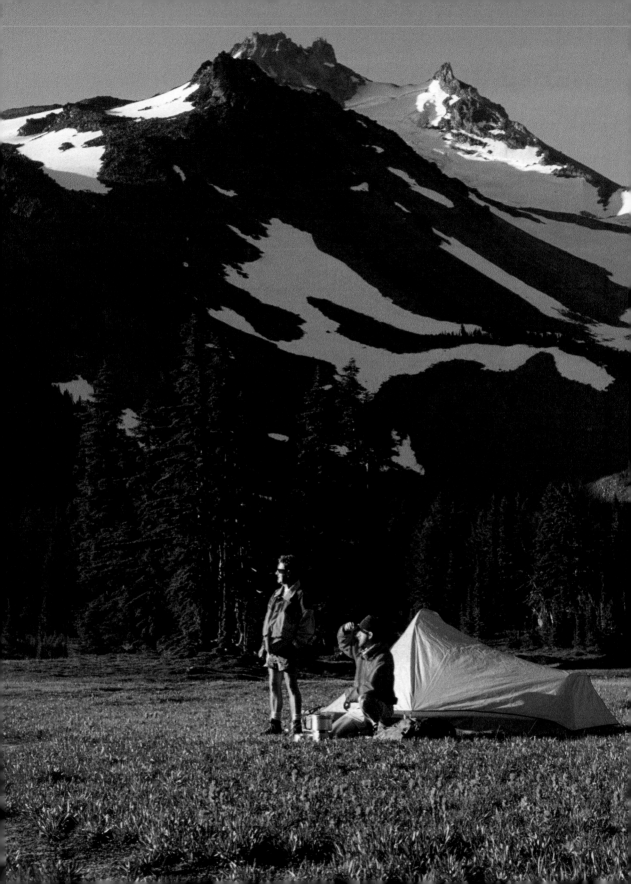

Top 10 Digital Photography Problems Solved

Problem 1: Your camera stopped working while you were busy taking pictures

If there is one universal truth in digital photography it is this – your battery power will run out just when you need it. Why? Because you won't know the batteries are out until you go to take a picture.

Well, this is not entirely true. Cameras have indicators of how much battery juice is left. But just like you would never get stuck in your car having run out of petrol, keep an eye on the battery indicator! And take extra batteries. Because as much as you think you will only take 50 shots and the batteries are good for 80, you will end up needing 100 shots and the batteries were only good for 60. It happens.

1 If your camera uses disposable batteries, carry an extra set in your camera bag.

2 If your camera uses a rechargeable battery (or set of batteries), be sure to charge up before heading out to take photographs. If you purchased an extra battery (batteries) charge those as well and bring them along.

Problem 2: Your pictures are blurry

Blurry pictures can occur when holding the camera by hand – a tripod can solve this. A tripod is a stand that holds a camera steady. When using a tripod you do not hold the camera to take the picture. This is necessary for certain types of photography – generally any photo shoot that involves a relatively long period that the shutter is open, or photographs taken at a high degree of zoom. Using a tripod removes the problem of being unable to hold the camera rock steady for more than a fraction of a second.

On the bottom of the camera is a threaded hole that allows the camera to be screwed onto the tripod.

1 Use a tripod.

2 Many tripods are low cost. You can keep an extra one in your car.

 HOT TIP: Tripods have removable plates with the screw post for the camera to go on, which fit into a holder on the top of the tripod. This lets you keep a plate screwed into the camera for easy attachment onto the tripod.

Problem 3: You're unsure how to take a picture of yourself

Your camera probably has a self timer with one or two settings. The self timer provides a countdown to the picture being taken. For example, a camera may have a two-second timer and a 10-second timer. Setting one of these and then pressing the shutter button provides a delay before the picture is taken.

The camera will have to be on a tripod or resting on a surface for this to work.

1 Put the camera on a tripod.

2 Set the timer for 10 seconds or whatever number of seconds gives you enough time to get in front of the camera.

3 Press the shutter button and pose in front of the camera. Audible and/or visual feedback lets you know when the picture has been taken.

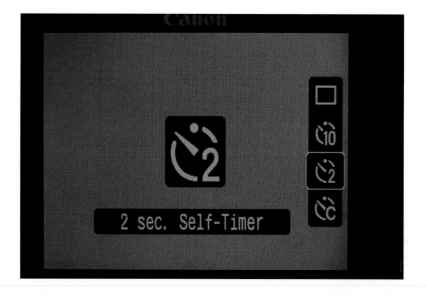

Problem 4: There's no room left on the memory card

Eventually your memory card will be full and no more pictures can be taken. You need to move and/or remove the images. There are a few actions you can take:

- Copy the images to your computer and erase them from the memory card.
- Swap the memory card for another one that is empty.
- Erase the images directly in the camera.

The first option is the one most people follow. You wish to save your photographs so copying them to your computer is essentially putting them into a more permanent storage medium.

Having more than one memory card is a good idea for the times when you are still taking photographs but have filled up your card. You can quickly change cards and keep shooting. Then the filled memory card can keep the images on it indefinitely. It is, after all, just another piece of memory hardware, just like a memory stick used for a computer.

Your camera provides methods for erasing the images from the memory card. You should be able to erase single images or erase them all at once. Consult your user manual.

DID YOU KNOW?
Copying and moving is not the same thing. When an image file is copied, the original is intact. To remove it requires a separate operation. Moving is the action of copying and erasing in one operation.

HOT TIP: Some software programs will copy and delete the images from the memory card at the same time.

Problem 5: You're unsure if you're allowed to take pictures of something without permission

Permission forms? Yes, if you do get serious about photography and take pictures of people, their children, their pets or their property, you might need their permission to use the images. This is not legal advice here, this is common sense. Cover your bases. Do an internet search for photography permission forms; ask a lawyer; or check with other photographers in your area.

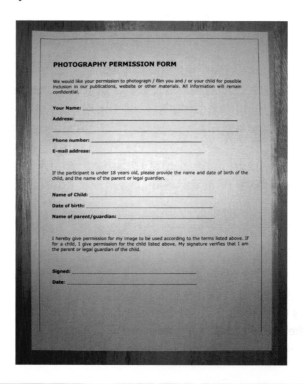

 HOT TIP: Also look into the 'fair use' of photographs. It might be permissable to take photographs that pertain to news items or celebrities. Find out before taking the photographs.

Problem 6: You can't see the camera settings at night

If you shoot any photographs at night you will have a hard time seeing the minutiae of the camera's menu system and perhaps some smaller buttons as well. A torch is necessary to see what you are doing when setting the exposure. It's one of those things you won't realise you need until it is too late. And don't forget extra batteries for the torch!

 HOT TIP: The torch you bring along should produce just a small beam of light. A bright torch will ruin your 'night vision'. There are torches that produce a red beam of light which is softer and less likely to affect your night vision.

 HOT TIP: There are torches you can wear around your head to keep your hands free. Similar to a miner's hat, the light is small and on an adjustable band. Any shop that sells a variety of torches should have this useful photographer's helper.

Problem 7: You want to take clear sport/action photographs

By the very nature of it, action shots – sports or otherwise – are candid shots. There is no posing. So follow these rules that apply to action photography:

- Keep shooting – if it makes sense leave your camera on burst mode (burst mode and the need for flash do not go hand in hand: that is why burst mode is usable only in well lit places).

- Use shutter priority – the key to capturing action is to 'freeze' it. This can happen only with a fast shutter speed. Outdoors, a shutter speed of 1/125 of a second is adequate. A speed of 1/500 or 1/1000 is better still. However, the lighting is part of the decision. Trying to shoot at a very fast speed without ample light will not yield a usable shot. Indoor action photography will probably need a speed that is slower but obviously not so slow that the subject gets blurred.

- Don't wait for a good shot – a good shot will pass you by before you realise you missed it! Take as many shots as you can and review them later.

 HOT TIP: To shoot a fast-moving sport, such as football, rugby or tennis, have more than one camera with you ready to go – with different settings in place. There is no time to fumble around with changing lenses or changing cameras. In sports photography you do not get second chances. Carefully place two cameras around your neck and be ready to switch quickly – with one set for a wide view (to shoot a team in action) and the other set to a zoomed in view (to get a shot of a single player).

Problem 8: You want an easy way to prepare your camera for a certain type of photography

On the settings dial will probably be some presets, indicated by symbols, and there may also be a scene setting. If there is a scene setting you should be able to access more presets somewhere within the menu system of the camera. There is no magic about the presets. What they do is set exposure, ISO and/or other settings to accommodate the type of photography being sought. For example:

- Action sets a fast shutter speed.

- Landscape sets a high f-stop (a small lens opening) so the range of focus is long in order to capture a large outdoor scene.

- Portrait sets a low f-stop (a large lens opening). The focus is a short range in order to capture the subject and leave the background soft and blurred.

- Twilight sets a slow shutter speed to capture the reduced light.

Each camera has a different mix of presets, and will even name the same ones differently. For example, one camera I have has a twilight mode, and another has a sunset mode. They are the same mode however. Here is a photograph I took of a particularly colourful sunset using twilight/sunset.

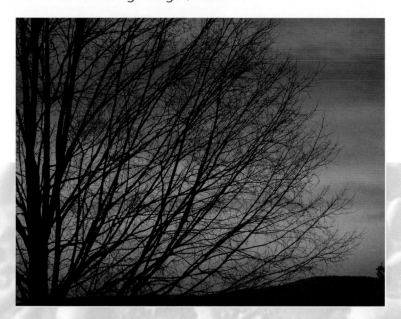

Problem 9: You can't quite get the sense of scale right in a photograph

It's natural for our eyes and mind to seek references in an image. If you view a picture of a person in a photograph, with nothing else in the picture, you cannot tell the height of the person. There is nothing to gauge their height against. Once another object is in the scene – another person, furniture, a tree, a car – really anything – then the person's height can be deduced. Perhaps not with complete accuracy, but certainly with two people in a scene, you can see their relative heights.

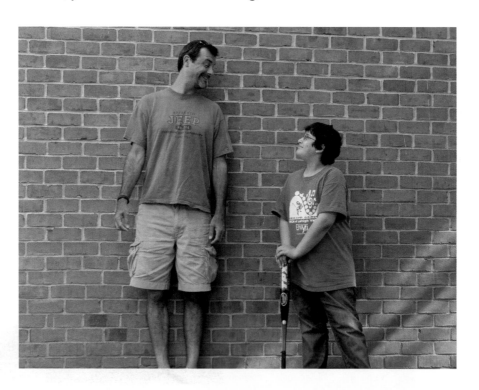

 HOT TIP: If you really need to show a sense of a person's height, take a shot of them sitting in a chair.

Problem 10: You're unsure where to place the subject in a photgraph

A standard composition technique is to use the rule of thirds. When setting a scene, place the subject along an imaginary line or point that is one-third to the left or right, and/or one-third towards the top or bottom.

This photograph places the centre of the balloons along the left and bottom thirds. With guidelines placed over the image it's easier to see how the subject is placed within the scene.

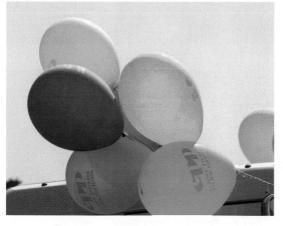

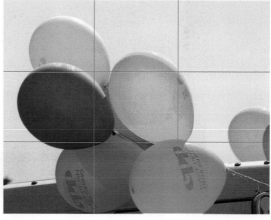

Use your computer with confidence

Office 2010 — 9780273736127

Excel 2010 — 9780273736134

Word 2010 — 9780273736141

Powerpoint 2010 — 9780273736158

Windows 7 — 9780273729136

Excel 2007 — 9780273723547

Office 2007 — 9780273723554

Laptop Basics Windows 7 Edition — 9780273736806

Computer Basics Windows 7 edition — 9780273736844

Windows Vista — 9780273723493

Laptop Basics — 9780273723486

Mac Basics — 9780273729297

Computer Basics — 9780273723479

Photoshop CS5 — 9780273736820

Photoshop Elements 8 — 9780273734390

Web Design — 9780273723530

Netbook Basics — 9780273734925

Windows 7 for the Over 50s — 9780273729181

Laptop Basics for the Over 50s — 9780273729129

Computer Basics for the Over 50s — 9780273729174

Practical. Simple. Fast.